SIGNALLING AND SIGNAL BOXES

Along the SE&CR Routes

Allen Jackson

AMBERLEY

For Ninette.

First published 2017

Amberley Publishing
The Hill, Stroud,
Gloucestershire, GL5 4EP

www.amberley-books.com

ISBN: 978 1 4456 6936 6 (print)
ISBN: 978 1 4456 6937 3 (ebook)

British Library Cataloguing in Publication Data.
A catalogue record for this book is available from the British Library.

Typeset in 10pt on 13pt Celeste.
Typesetting by Amberley Publishing.
Printed in the UK.

Contents

Introduction

The Southern Railway consisted of the following pre-Grouping companies for which an identifiable signalling presence exists: London, Brighton & South Coast Railway (LBSCR), Isle of Wight Railway (IOWR), South Eastern & Chatham Railway (SE&CR), and London & South Western Railway (LSWR).

This volume is the second in a trilogy about the former Southern Railway; the first volume contains information about ways of working, signal box lever designations and other information.

The SE&CR was the result of a previous merger between the South Eastern Railway (SER) and the London Chatham and Dover Railway (LCDR). The two companies carried on operations as before up until grouping on 1 January 1923 so the SE&CR moniker was largely an administrative function.

Summary of Contents

South Eastern & Chatham Railway (SE&CR)

NORTH and EAST KENT to DOVER and the ISLE OF GRAIN
Stone Crossing
Grain Crossing
Rochester
Gillingham (Kent)
Rainham
Sittingbourne
Teynham Crossing
Faversham
Margate
Ramsgate
Sandwich
Deal
Dover Priory

CANTERBURY AREA and FOLKESTONE HARBOUR
Minster
Sturry
Canterbury West
Chartham
Wye
Canterbury East
Shepherdswell
Folkestone East
Folkestone Harbour

MAIDSTONE AREA and the SOUTH COAST
Cuxton
Snodland
Aylesford
Maidstone West
Maidstone East
East Farleigh
Wateringbury
Robertsbridge
Mountfield Ground Frame
Bopeep Junction
Hastings
Rye

WESTERN AREA
Wokingham
Reigate
Oxted

South Eastern & Chatham Railway (SE&CR)

The SE&CR was formed as a result of a merger between the South Eastern Railway (SER) and the London Chatham & Dover Railway (LC&DR) in 1899.

The two companies had fought over the Kentish spoils and eventually decided that a truce or even a merger was preferable to more conflict. The suburban passenger network traffic was and is some of the densest and busiest passenger railway in the world, and into this mix the SE&CR was interleaving the running of principal expresses to connect with the cross-channel ferries at Ramsgate, Dover and Folkestone. There was some freight traffic generated from the Chatham and Medway areas on the south bank of the River Thames and the East Kent coal field. Kent has always been renowned as a fruit and hop growing area. The SE&CR pioneered the mass movement of troops in the First World War from Richborough, between Sandwich and Ramsgate, with the first roll-on, roll-off train ferries for the movement of heavy equipment.

North and East Kent to Dover and the Isle of Grain

The route to the Kent seaside resorts of Margate and Reamsgate was used not only by Londoners wishing to escape for a day trip but was served by direct rail services from places like Birkenhead. The North Kent line also saw industry and freight traffic for the Rivers Medway and Thames. Ramsgate is also a cross-channel ferry port. There are smaller resorts at Herne Bay, Broadstairs, Sandwich and Deal.

Dover has long been the sea gateway to England from France and a national fortress in time of war.

Fig. 1 is a not-to-scale schematic and simplified diagram of the route. The journey begins just after Dartford on the south bank of the River Thames.

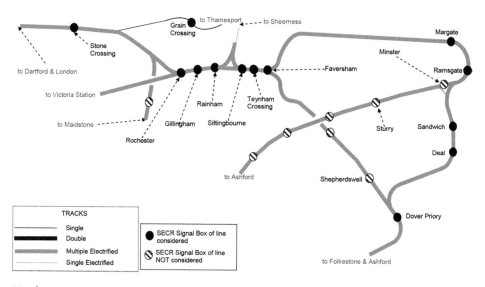

North & East Kent: Stone Crossing to Dover Priory.

Stone Crossing (ST)

Date Built	SE&CR Type or Builder	No. of Levers or Panel	Ways of Working	Current Status (2016)	Listed Y/N
circa 1904	SER	5	Gate	Active	N

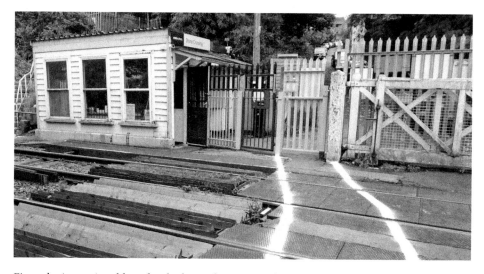

Fig. 2 depicts a signal box that looks as if it were under siege, which to some extent it is. The road crossing has been risk assessed as being too dangerous to remain open and now has the ubiquitous Network Rail fencing as a permanent barrier. The vertical steel rod on one of the gates was required to engage in a locking mechanism when the gates were closed against the railway. October 2015.

Stone is mainly a commuter village but also has the Thames Europort facility nearby, which is a roll-on, roll-off berth for freight-carrying vessels. Stone Crossing is referred to as a 'gate box' in that it controls the road and pedestrian crossing over the railway but not the passage of trains along a block of track. The passage of trains here is controlled by Ashford Area Signalling Centre at the time of writing in 2016 but will inevitably end up being controlled by the South Eastern Rail Operating Centre (ROC) at Gillingham.

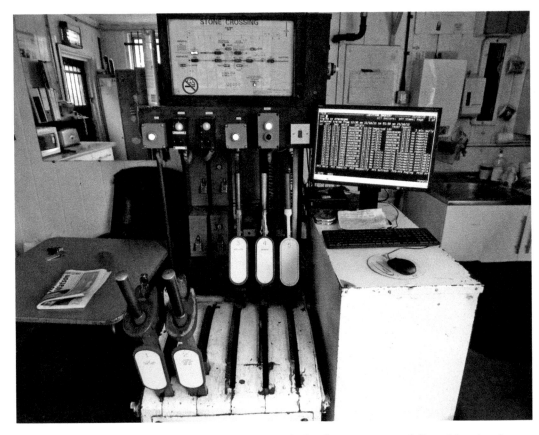

Fig. 3 is the interior of Stone Crossing signal box with the diagram up top, followed by signal indicator lights with the five lever frame towards the bottom of the picture.

The diagram shows the signals in the vicinity but not their indication status. That is reserved for the row of lights below the diagram.

The diagram is at odds with the conventional north-orientated view of the line at Fig. 2. In other words, to the right on the Up line is Dartford and Charing Cross while to the left the Down line is towards Hoo Junction and the Isle of Grain and Rochester. The two lights together, on the left, are showing a train occupying a track circuit heading for Charing Cross in London. The light on the lower right-hand side simply shows that there is electrical power to the diagram. The gradient profile is at the top of the diagram and, as we are alongside a river bank, the profile is very nearly flat. The destination on the left is shown as Northfleet, which is the next major station towards Rochester and right next to Ebbsfleet International on the HS1 route from St Pancras to Europe. All three signal indicators are shown as OFF or green. 2015.

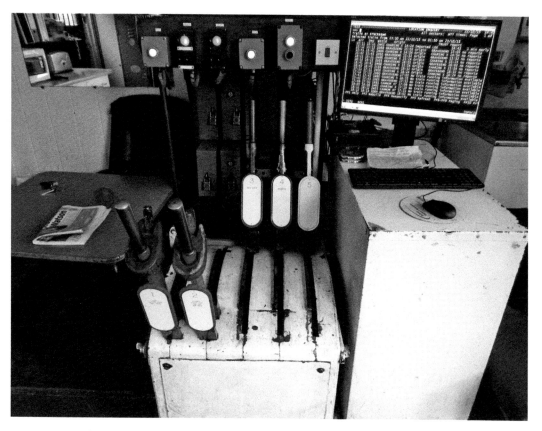

Fig. 4 is the lever frame and TRUST computer screen. The NEC Multisync monitor or TRUST (Train RUnning SysT) screen is a continually updated forecast of the Working Time Table (WTT), which covers any train movements – not just those of passenger trains. The display is showing a continual procession of trains to and from Gravesend and Charing Cross. This display has supplanted the electro-mechanical train describer system which the SE&CR, SR and BR used at busier locations. TRUST shows arrival and departure times and any delay incurred. 2015.

The lever frame's functions and levers, as shown in Fig. 4, are as follows, from the left:

Lever 1 Up Slot on Signal NK 416
Lever 2 Down Slot on signals NK 411 and NK 413
Lever 3 Gate Lock (the main gates across the tracks)
Lever 4 Wicket Gate (the side pedestrian gates)
Lever 5, coloured white, is a spare

Levers 1 and 2 do not actually change any signals, although they are coloured red, but they either inhibit or enable the signals to be changed over by Ashford. This process is known as 'slotting' and, when the levers are towards the diagram (normal position), it means the gates are closed against the railway. As here, the gates are permanently locked against the road and so the levers are in constant 'enable' the signal mode and are pulled back towards the signaller, or 'reversed'. Note the signal 'lever collars' that prevent the

levers being put back to normal towards the diagram. The Down slot releases two signals, so this would indicate a higher speed than on the Up and the extra signal is to give the train additional time to stop if the gates were closed against it. The gate and wicket levers remain in the 'locked against the road' mode (normal) and the signaller now manually locks and unlocks with a padlock the pedestrian gates that allow passengers to access the Down platform.

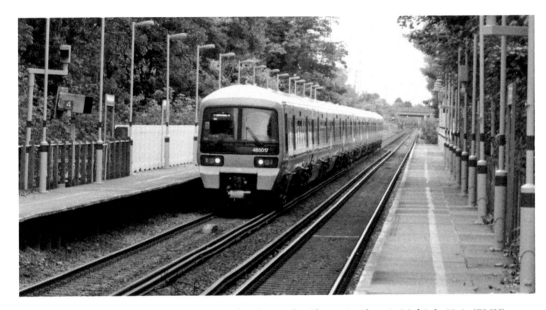

In Fig. 5, the signal box has a customer in the shape of a Class 465 Electric Multiple Unit (EMU) No. 465017 heading up for Charing Cross and not stopping at Stone Crossing station. Note that the third rail is kept away from platform edges, and also the aspects of the two signals down the line. October 2015.

Stone Crossing signal box is 19 miles and 14 chains (30.86 km) from Charing Cross via the Dartford Loop.

The journey next continues eastwards for just under 8 miles (13 km) to Hoo Junction, where the branch is taken for the Isle of Grain and the Foster Yeoman complex. Hoo Junction often sees Class 73 electro-diesel locomotives and a Class 08 shunter. The single track to Grain is not electrified.

Grain Crossing (–)

Date Built	SE&CR Type or Builder	No. of Levers or Panel	Ways of Working	Current Status (2016)	Listed Y/N
1882	SER Stevens	9	NSKT	Active	Y

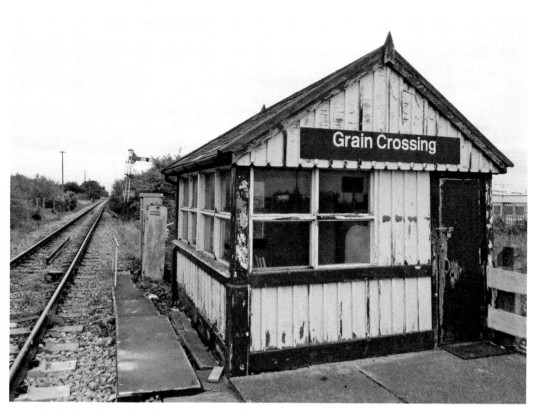

Grain Crossing is that former SE&CR oddity in that it has semaphore signals and non-electrified track. Here in Fig. 6, the view is towards the Foster Yeoman terminal. It is also a listed building and Historic England cites the fact that the box is the only surviving structure from the contractors Stevens & Sons. It is also unusual in being single-storied above ground; most boxes have the ground floor for the locking frame and the first floor as the operating space. It contains an original Stevens locking frame and levers, as well as the key token machine. October 2015.

The Isle of Grain is the most easterly point of the Hoo peninsula and is an important junction of the Rivers Thames and Medway for trade and industry.

The No Signaller Key Token (NSKT) section stretches from Cliffe Sidings ground frame, where the sidings are located, to a Lafarge aggregates facility off the branch. The token is issued at Cliffe Sidings in the Down direction towards Grain Crossing and the driver then places the token in the machine at the key token apparatus at Grain Crossing when the train has travelled that section.

A reverse trip in the Up direction towards Hoo Junction needs the train driver to access a token at Grain Crossing and proceed with it to Cliffe Sidings ground frame.

Grain Crossing signal box is 38 miles and 22 chains (61.6 km) from Charing Cross via the Dartford Loop.

The journey now resumes towards Margate.

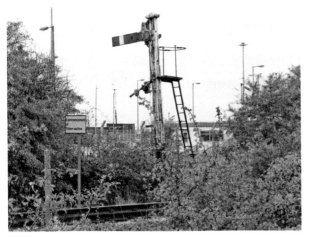

Fig. 7 is the front view of the signal in Fig. 6; the sign advises the train driver to stop the train, dismount, and to go in the signal box and acquire a token for the section to Cliffe Sidings ground frame. The Southern Railway semaphore signal is quite distinctive with old bull head rail bolted together for a post and the operating lever way up the post – no doubt out of the way of the third rail, where there is one. October 2015.

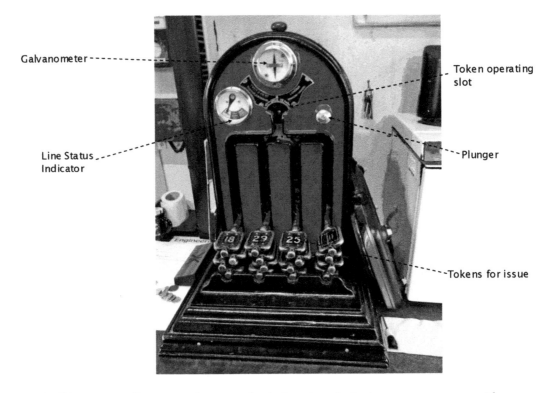

Galvanometer

Token operating slot

Line Status Indicator

Plunger

Tokens for issue

Fig. 8. This system relies on an electro-mechanical system devised over 100 years ago. The principle is that a train driver is issued with a physical token for the section of track that the train is travelling on and no other. This has the action of enabling signals that are in the direction of travel of the token-bearing train to be pulled off or go and the other signals in the opposite direction on the line to be locked at danger or at 'on'. Only when the token is restored in the token machine at the end of the section being travelled is the interlock broken and a train can then be sent in the opposite or same direction down the single line. The term 'no signaller' means that the train driver operates the token apparatus and assumes responsibility of proceeding with the correct token for the section; the train driver is also responsible for the operation to secure the token within the machine at the other end of the section. October 2015.

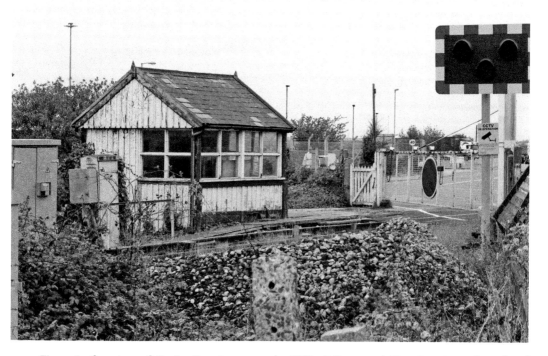

Fig. 9 is the view of Grain Crossing towards Cliffe Sidings and Hoo Junction. The pile of ballast in the foreground is about where the platform for Grain Halt was located. This platform serviced workers' trains. October 2015.

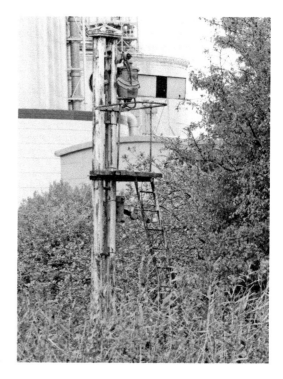

Fig. 10 is the rear view of the signal on the opposite side of the crossing. The arc-shaped back light cover shows up well where this item obscures the small light emitted from the rear of the signal so that the signaller knows the signal has answered the lever in darkness. There is no requirement for a signal arm position transmitter here or across the crossing for the other signal. The ladder here is side mounted as a safety feature. October 2015.

Rochester (ER)

Date Built	SE&CR Type or Builder	No. of Levers or Panel	Ways of Working	Current Status (2016)	Listed Y/N
1959	BR Southern Region Power Box	Nx Panel	TCB	Closed	N

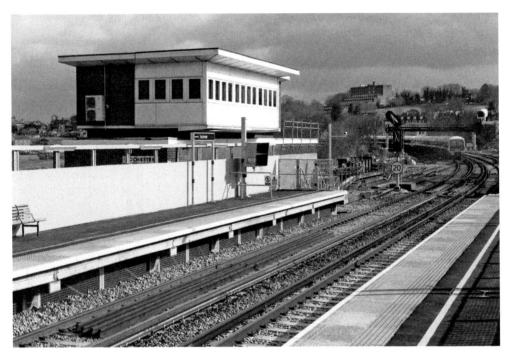

Fig. 11 and Rochester signal box is hanging on in there and still retains the original name, although this is usually removed on closure. The style of architecture might be described as post-Festival of Britain municipal prosaic. Class 465 No. 465162 is heading off towards Chatham and Gillingham. However, it is not by means of the signal marked with the white cross, as this indicates that the signal is not in use yet. The River Medway can just be seen on the left. March 2016.

Rochester has long been a port on the River Medway, and its lowest bridging point. The castle was fought over in ancient times and the town will forever be associated with Charles Dickens, who lived nearby for many years and based many of his novels around the local area. Charles Dickens travelled extensively by rail and was a victim of an early railway accident.

The station is near the site of the junction with the direct line to Victoria station, and the tracks are elevated on a series of arches, which seems a prudent strategy in view of the proximity of the River Medway.

The signal box was part of the East Kent Electrification project in 1959 and was equipped with an Nx Panel. The panel contains a diagrammatic representation of the

section covered, on which are switches that control points and signals. The points and signals are interlocked by relays rather than mechanical locking with lever frames.

This acronym signified 'eNtrance' and 'eXit', meaning that the panel covered a certain section of tracks and from which a route could be set from one side to the other by the operation of a single switch. This is dependent on all the point and signal switches being set to automatic mode. If they are set to manual mode then the signaller could select points and signals separately but would still be dependent on the relay locking.

Rochester station was demolished and a new station built around the site of the signal box, which had been some way (19 chains or 380 metres) from the original station.

Rochester signal box is 33 miles and 42 chains (53.95 km) from Victoria station via Herne Hill.

Gillingham (Kent) (ET)

Date Built	SE&CR Type or Builder	No. of Levers or Panel	Ways of Working	Current Status (2016)	Listed Y/N
1913	SEC Rlwy	44	TCB	Closed	N

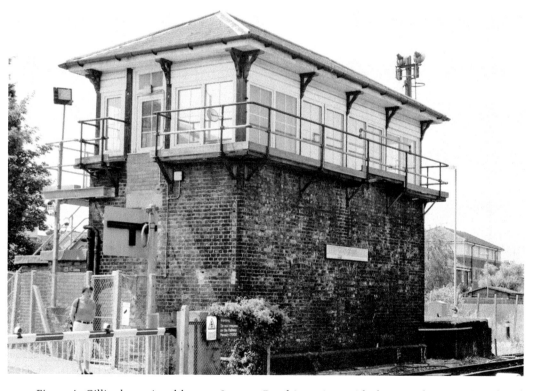

Fig. 12 is Gillingham signal box on Ingram Road in action, with the attendant crossing closed to pass a train. Note how the original doorway has been blocked off and a separate means of accessing the operating room tacked on at the rear. Note also the curved top to the locking frame room windows, which have been bricked up. The box retains its Network South East name board from the 1990s. July 2013.

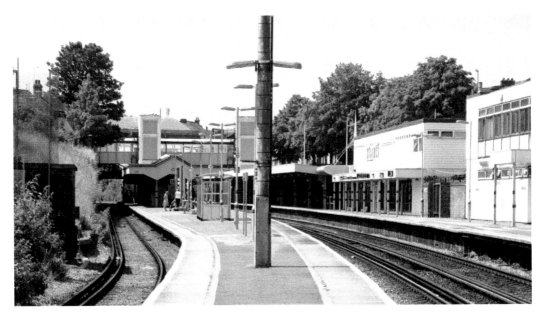

Fig. 13 is the 180-degree view from Fig. 15 with Gillingham station buildings in a style that could be described as pre-war modernist. July 2013.

Gillingham's history over the last 400 years has been connected with the Royal Dockyards at Chatham, whereas a good deal of it was actually in Gillingham. A stub of the branch line to the dockyard still exists in 2016, although the Royal Navy departed in 1984. This line has no third rail. There was a steam depot at Gillingham, a sub-shed to 73F Ashford.

Gillingham signal box is 33 miles and 42 chains (53.95 km) from Victoria station via Herne Hill.

Rainham (EU)

Date Built	SE&CR Type or Builder	No. of Levers or Panel	Ways of Working	Current Status (2016)	Listed Y/N
1959	BR Southern Region Type 17	Nx Panel	TCB	Closed	N

Rainham has been characterised as a part of Gillingham but is attractively situated at about 400 feet (125 metres) above the River Medway on a slope of the Kentish North Downs.

The railway needed to install passing passenger loops on both tracks here as an indication of the volume of rail traffic hereabouts.

Rainham signal box is 39 miles exactly (62.76 km) from Victoria station via Herne Hill.

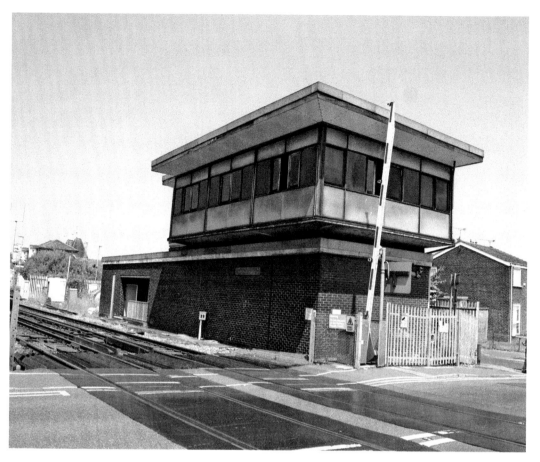

Fig. 14. Rainham signal box is another of the East Kent electrification signal boxes but with a Siemens General Electric type of Nx Panel. On a more historic note, the Kentish oast houses are in the background. These are a familiar scene in Kent, where they were originally used for the drying of hops for beer production but now are often converted into dwellings. Also noteworthy is the 39-mile marker post outside the box. July 2013.

Sittingbourne (EV)

Date Built	SE&CR Type or Builder	No. of Levers or Panel	Ways of Working	Current Status (2016)	Listed Y/N
1959	BR Southern Region Type 17	Nx Panel	TCB	Closed	N

Sittingbourne is well known as a producer of paper and the Sittingbourne & Kemsley preserved railway was originally owned by Bowater's, the paper company. Brick making and barge building were also local industries. The Sittingbourne & Kemsley preserved railway is also 2 foot, 6 inch (760 mm), the same as the Chattenden & Upnor Railway near Gillingham; this is an unusual narrow gauge for Britain.

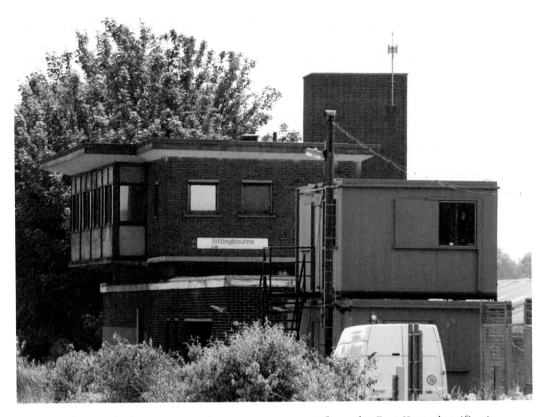

Fig. 15 is the standard structure we have come to expect from the East Kent electrification but this time it has an Nx Panel by General Electric Transportation Systems, who had parted company from Siemens by the time they got to Sittingbourne. July 2013.

Sittingbourne is also the junction for the line to Sheerness, with docks as well as passenger carrying to Sheerness station.

Sittingbourne signal box is 44 miles and 59 chains (72 km) from Victoria station via Herne Hill.

Teynham Crossing (–)

Date Built	SE&CR Type or Builder	No. of Levers or Panel	Ways of Working	Current Status (2016)	Listed Y/N
1970	British Railways Southern Region	5	Gate	Closed	N

Teynham is a largely agricultural village, with fruit and hops grown nearby. The station had its original 1858 building demolished in 1970 and the present temporary structure erected. The signal box is an amalgamation of old parts and the newer station building.

Teynham signal box is 47 miles and 79 chains (77.23 km) from Victoria station via Herne Hill.

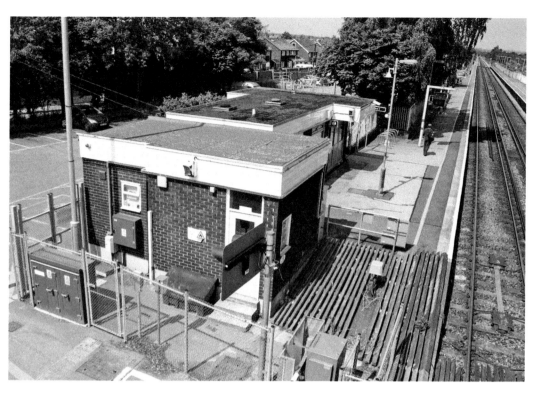

Fig. 16. The signal box depicted is the small building nearest to the barrier. There had been manually operated gates to the railway cottages here across the tracks until the automatic barriers were installed and signal box closed in 2011. The view is towards Sittingbourne, which is about 3 miles (5 km) to the east. July 2013.

Fig. 17 is a survivor from the original 1858 buildings in the shape of the goods shed, which is just by the Up platform at Teynham station. July 2013.

Date Built	SE&CR Type or Builder	No. of Levers or Panel	Ways of Working	Current Status (2016)	Listed Y/N
1959	BR Southern Region Type 17	Nx Panel	TCB	Closed	N

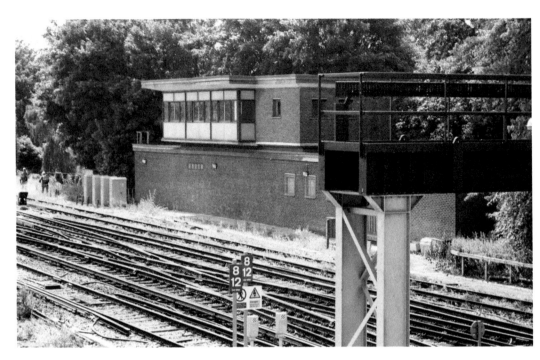

Fig. 18 sees the box sitting opposite an updated signal on the far left, controlled from the East Kent Signalling Centre at Gillingham and plated as such. Note the ground signal outside the box that has a caption indicator for more than one route. July 2013.

The town of Faversham is an ancient and historic borough with an industrial past concerned with explosives and brewing. The brewing is still a major activity in the town.

Faversham is the junction of the lines from Margate and Canterbury. The station and some original buildings from 1858 survive but the signal box is another 1959 innovation from when the line was electrified. However, this box differs again from its neighbours at Sittingbourne and Rainham in that it has a third different type of Nx panel manufacturer. The General Railway Signalling Co. was founded in Rochester in New York State in the US. It is now part of Alstom. The panel also differs in that, while lights are usually provided to indicate point and signal position, in the GRS case points are indicated by a moving coil meter movement on the track diagram. The mechanism is much like an absolute block instrument. This is so unusual that the National Railway Museum have asked that the panel be part of their collection.

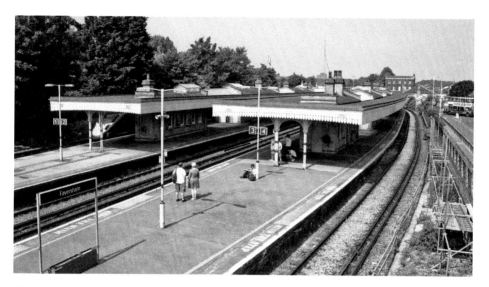

Fig. 19 shows the original 1858 station platform buildings still providing a service after more than 150 years. A Class 395 Javelin waits momentarily in Platform 1 before continuing its journey to St Pancras over HS1. July 2013.

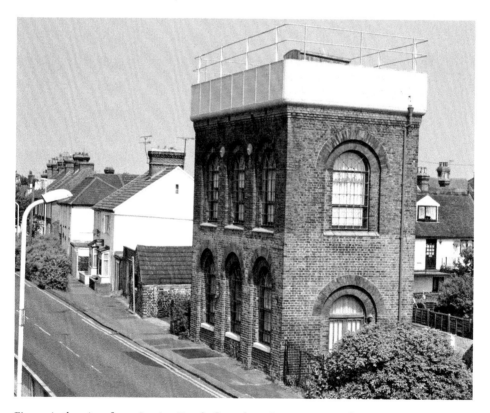

Fig. 20 is the view from Station Road of another 1858 structure. The water tower supplied the water cranes that replenished steam engine tanks and tenders, although it is now a residence. It is unusual for the tank to survive intact in these situations. July 2013.

There was a steam depot at Faversham, coded 73E under British Railways.

Faversham signal box is 52 miles and 7 chains (83.83 km) from Victoria station via Herne Hill.

The journey now takes the northern branch to Margate via Whitstable, the historic home of the oyster industry.

Margate (GE)

Date Built	SE&CR Type or Builder	No. of Levers or Panel	Ways of Working	Current Status (2016)	Listed Y/N
1913	SEC Rlwy	80	TCB	Demolished 2013	N

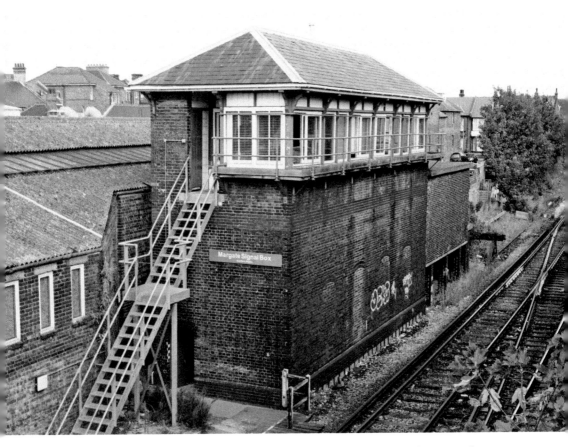

Fig. 21. Seen here is a signal box designed by John Tilly – Margate West. There was also Margate East signal box at one time; at eighty levers it is easy to see how extensive the facilities were here. The view is towards Margate station and Ramsgate.

The staining on the brickwork beneath the windows is characteristic of generations of signallers emptying the box teapot. The brick building behind the signal box is a locking room for the relay locking that was installed when the line was electrified and converted to colour light signalling in 1959. September 2008.

Margate is a seaside resort that owes its rapid growth in the nineteenth century to the arrival of the railway. It is one of those resorts that is close enough to enable day trips from London and yet, for many years, there were trains that ran from Birkenhead Woodside to Margate over the GWR through Chester and Wolverhampton to Reading (SE&CR) and then Ashford. A buffet car service left Birkenhead until the cessation of steam and through services together in 1967.

The SR built a new station in 1926, designed by Edwin Maxwell Fry, which is now Grade II listed. The station was Margate West until 1953 when Margate East was closed.

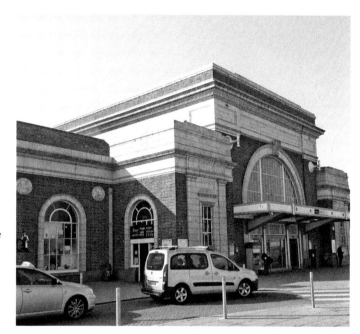

Fig. 22. The Southern Railway splashes out and builds a station worthy to welcome any visitor. The view the other way is of the harbour and the sands so day trippers were doubly delighted and no doubt relieved that there was not a lengthy trek or bus ride to the beach. March 2016.

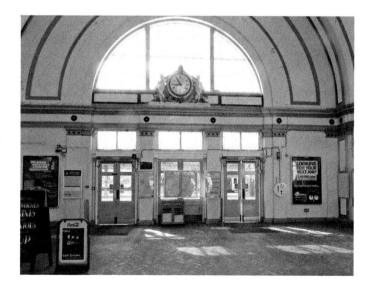

Fig. 23 sees the expansive style of the frontage carried on inside the station main hall with a South Eastern Railway clock and garniture that was presumably brought here from Margate East or some other part of the SER system. March 2016.

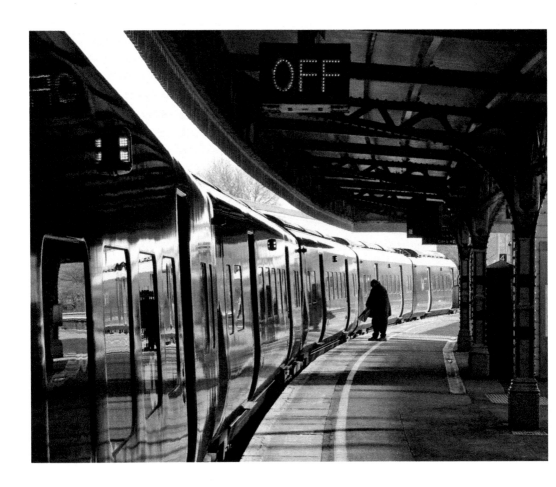

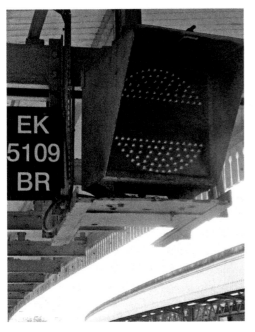

Above: Fig. 24. Margate is now a high-speed destination with the advent of Class 395 Javelin trains.

The OFF caption refers to a signal at the end of the platform that is out of sight of the guard/conductor, due to the curvature of the platforms and possibly the canopy. It is an indication that the signal aspect is green or go. The indicator is superfluous in this instance as we can see the reflection of the green LED signal on four of the EMU coaches. March 2016.

Left: Fig. 25 is another example of repeating the aspect of a signal, this time to a train driver. The Banner Repeater for East Kent signal 5109 would inform a driver that the signal at the end of the platform, 5109, is at danger. This type of indicator hails from steam days but has been updated with an LED array display to represent a semaphore signal at danger in this case. March 2016.

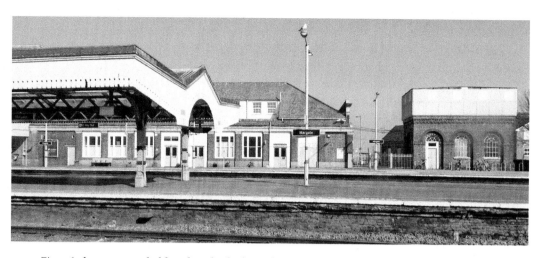

Fig. 26 shows us probably what the locking frame windows were like on the signal box before they were removed. The Steam Age water tower has its windows intact as the ground floor would still appear to have a railway use. Fry's station building continues to a dignified end on the platform. March 2016.

Margate station is 73 miles and 69 chains (118.87 km) from Victoria station via Herne Hill.

Ramsgate (HE)

Date Built	SE&CR Type or Builder	No. of Levers or Panel	Ways of Working	Current Status (2016)	Listed Y/N
1926	S R Type 11a	88	TCB/AB	Active	N

Fig. 27: the bane of photographers' lives at Ramsgate has been an EMU parked in front of the box. This seems to be due to the fact that the platform and line nearest the box are stabling areas for such vehicles. The lights on stanchions tend to reinforce this view. Although the box has been superseded by the East Kent Signalling Centre the box nameplate was still attached in 2016.

Note the cast-concrete trough trunking coming out of the relay room nearest the camera that this seems to be used as a walkway by servicing staff. Behind the box are the EMU sheds, which were updated in the late 1950s from the steam shed here. The steam depot at Ramsgate was a sub-shed to 73F Ashford. August 2009.

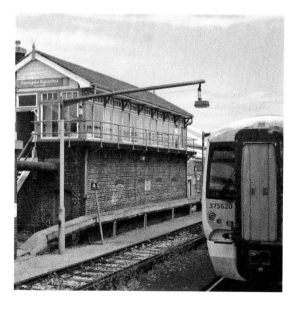

Ramsgate too was a railway creation in the sense of being a top-class seaside resort but it also owed this to other factors such as the fishing and cross-channel ferry traffic. Ramsgate is as much a port as a holiday destination. The port provided a haven for Dunkirk evacuees in 1940 and the Southern Railway used eighty-two trains to transport Ramsgate's part of the rescued British Expeditionary Force (BEF).

The mileage changes here and Ramsgate signal box is 85 miles 61 chains (138.02 km) from Charing Cross via Chelsfield and Canterbury West.

The journey now travels past Minster East Junction and on to the East Kent line to Dover Priory. The line passes Richborough Sidings signal box, which is now derelict.

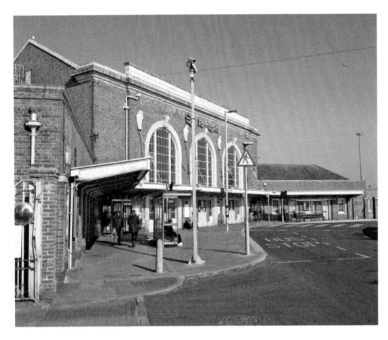

Fig. 28 depicts Ramsgate station frontage and this too was thought to be the work of Edwin Maxwell Fry, and is Grade II listed. The station is on a slightly less grand scale than Margate but is imposing nonetheless. It has four platforms, whereas Margate did have five but now has now four. March 2016.

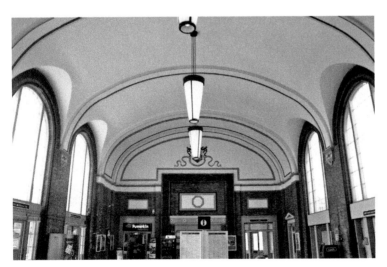

Fig. 29 is the ticket hall at Ramsgate and the lights seem to be of the Art Deco period of the building's construction. The coat of arms at the end is of the Southern Railway. August 2009.

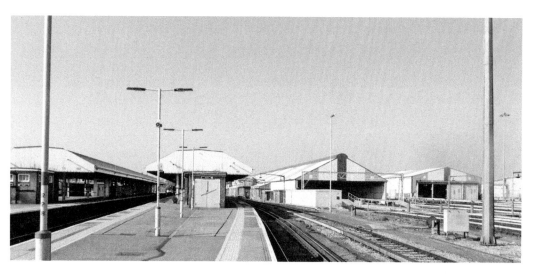

Fig. 30 is a shot of the platforms and EMU sheds. The box is opposite the platforms backing onto the EMU sheds and a Class 395 and Class 375 lurk in the platforms. Note how the third rail is boarded in at the sides where staff from the depot have to walk. The depot consists of twenty-five roads and has been modified again to accommodate Class 395 Javelin trains. The view is towards Minster and Canterbury. March 2016.

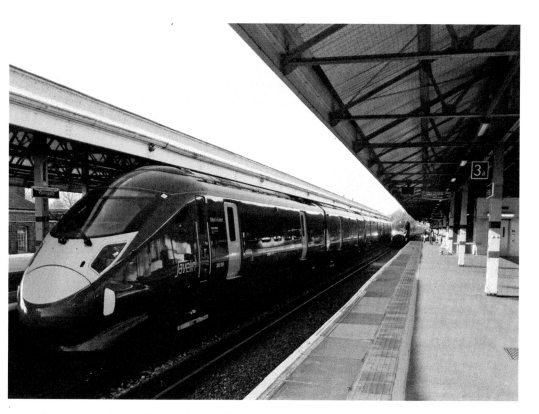

Fig. 31 was taken mid-morning at Ramsgate; the nearer Class 395 is No. 395009 *Rebecca Adlington*. March 2016.

Sandwich (SW)

Date Built	SE&CR Type or Builder	No. of Levers or Panel	Ways of Working	Current Status (2016)	Listed Y/N
1938	SR Type 11b	IFS Panel	AB TCB/AB	Active	N

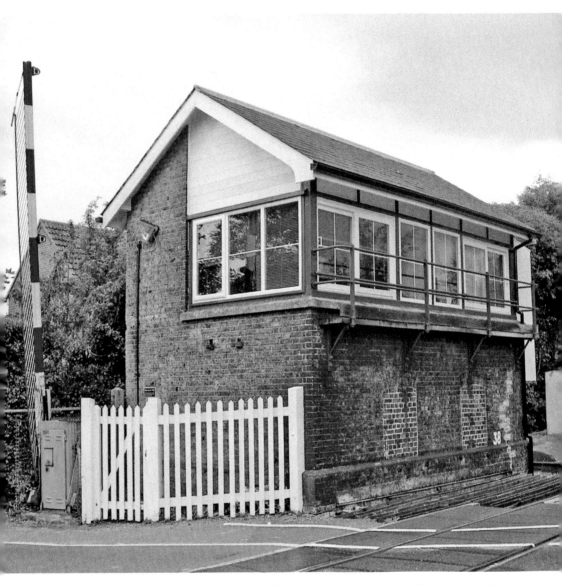

Fig. 32 shows the box that supervises a road crossing and retains its walkway at the front at least. Many of these walkways on signal boxes up and down the country have been removed, as they are usually supported on ancient cast-iron brackets, which are seen as life expired. However this box is a relative youngster at less than eighty years of age at the time of writing. August 2009.

As with Ramsgate, Sandwich is a Cinque Port; although it is now some way from the sea, it is on the River Stour. Sandwich also merited a through coach on the aforementioned Birkenhead Woodside trains until 1967.

Up until the 1960s there had been an extensive goods yard here; the ends of the sidings were behind the box on what is now the small housing estate.

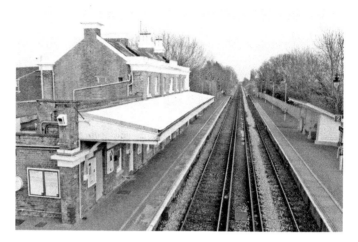

Fig. 33: Sandwich station building is Grade II listed and dates from 1847, which is surprising as the building has a more modernistic appearance. The later extension, nearest the camera, dates from 1892. Even the small waiting shelter on the opposite platform has fine detail wooden parts. The view is towards Deal and Dover Priory. March 2016.

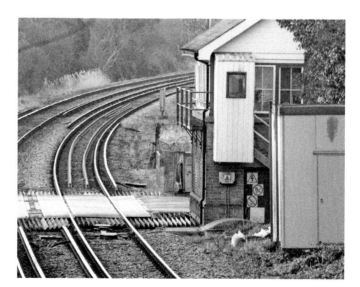

Fig. 34. The opposite view towards Ramsgate this time and the crossing of the Dover Road. March 2016.

Sandwich signal box is 86 miles 38 chains (139.17 km) from Charing Cross via Chelsfield and Canterbury West.

The journey continues past the site of Betteshanger Colliery, where there was once a signal box, to Deal.

Deal (EBZ)

Date Built	SE&CR Type or Builder	No. of Levers or Panel	Ways of Working	Current Status (2016)	Listed Y/N
1939	SR Type 13	42 Westinghouse A2	AB	Active	N

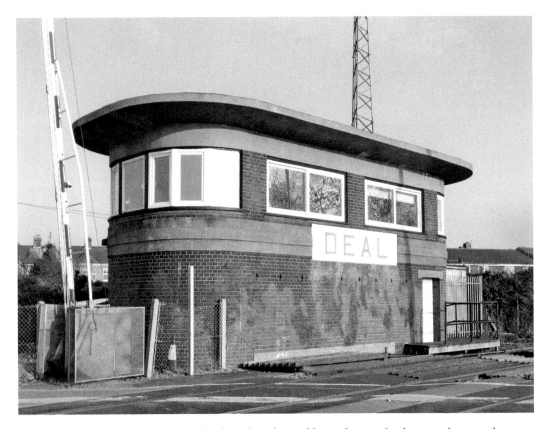

Fig. 35. It is hard to believe that Sandwich and Deal signal boxes have only about twelve months between them as to construction date. Deal is in the Art Deco mini 'Odeon' cinema style with rounded corners and large picture windows. March 2016.

Deal's history has been varied and colourful. It developed as a fishing port and smuggling centre but also has a Tudor castle and historic barracks connected latterly with the Royal Marines. It is also a seaside resort with a Grade II listed pier, sands and a conservation area town centre.

However, the railway interest is just as historic, with absolute block working and semaphore signalling. It is almost as if the railway is in a conservation area too.

The survey consists of two mini journeys. The first is from the north of Deal southwards and the second in the reverse direction.

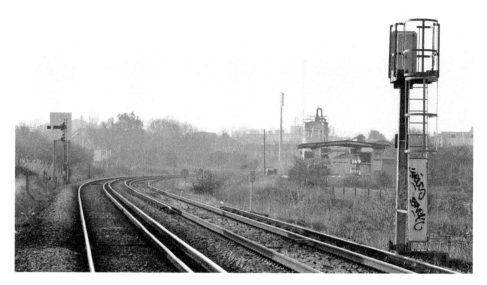

Fig. 36 shows the view from Northwall Road crossing looking south towards Deal station and Dover. The first semaphore signal encountered is on the left and has a sighting board to help the train driver pick it out from the background clutter. From here the line curves round towards the sports ground and builder's merchant before reaching Albert Road crossing, which is where the signal box is. March 2016.

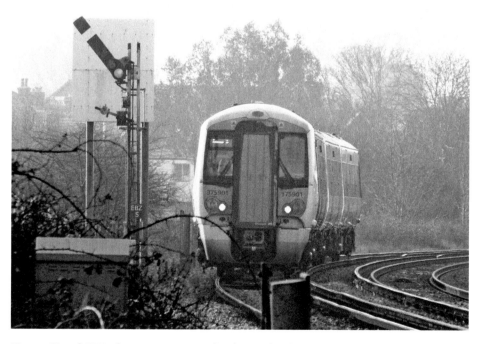

Fig. 37. Signal EBZ 5 has a customer in the shape of a Class 375, No. 375901, heading south for Deal station in the early morning. The signal has lost its finial – and note the large sighting board supported by two posts. March 2016.

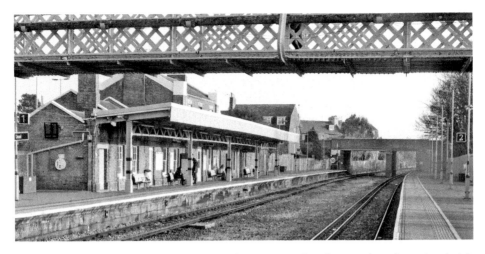

Fig. 38. Deal station had originally been the terminus for the SER line from Sandwich in 1847 and consisted of the single platform seen here. When the SER and LCDR got together to extend the line to Dover the siding next to the platform was extended to become a 'through siding'; the works were completed in 1881. This accounts for the wide gap between the tracks and that the London Road bridge at the end of the view can accommodate three tracks.

Note the semaphore starting signal on the Up platform, which incidentally is 'up' towards Dover. This is distinctly odd as most lines go up to London; however, the SER would view the route via Dover and Canterbury to London to be up. Behind the station building and to the left is a Sainsbury's store – this was the site of sidings and a goods yard, locomotive depot and turntable were on the opposite side of the tracks. March 2016.

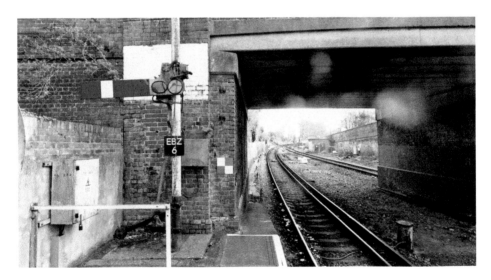

Fig. 39. This is the previously viewed signal, EBZ 6; the signal arm is lower down the post than usual so that it is still visible, with the Platform 1 canopy in the way. The grey gadget to the right of the blue lens is a position transmitter. The line assumes ordinary double track geometry shortly after the bridge but not before a trailing crossover. The device at rail level, almost opposite the signal, is a flange greaser, meaning a sharp curve ahead. March 2016.

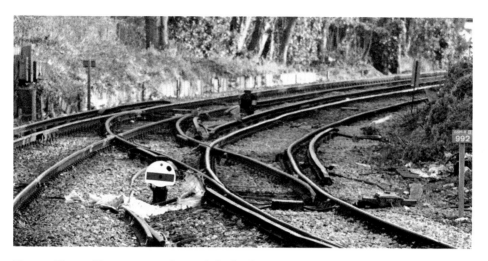

Fig. 40. The trailing crossover beyond the bridge is shown here, complete with a ground disc at the toe of each point to signal a reversing move over the crossover. Here we have a piece of semaphore signalling modernity in the shape of two signs that bear the GSM-R telephone number of Deal signal box, 992. By the right-hand GSM-R post is a grey point motor. The pigeons standing on the live conductor rail have very wisely decided not to try to stand on the running rails at the same time. March 2016.

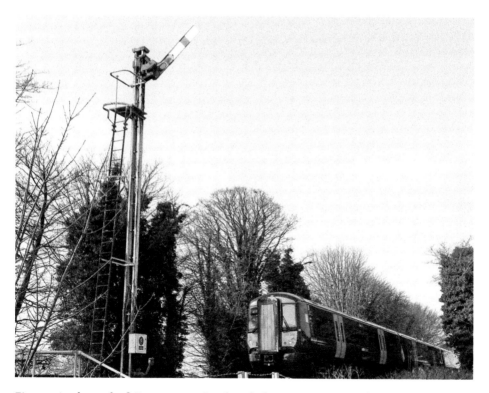

Fig. 41. At the end of Ravenscourt Road and almost opposite Deal Castle, which is by the beach, this signal is controlling the southern exit from Deal. Class 375 No. 375306 accelerates for Dover Priory past signal EBZ 7. March 2016.

The mini journey now starts in the opposite direction on its way north to Deal station.

Fig. 42. Signal EBZ 41 resembles the end of platform starter we saw in Fig. 39, but is the first semaphore signal travelling north. The view this time is from Victoria Park on the other side of the line to Fig. 41. The height of the ladder suggests that the arm was higher up the post originally. The telephone box with the black-and-white diagonal stripes is an imperative to the train driver, in that if the train is held at the signal the driver is to telephone the signaller. March 2016.

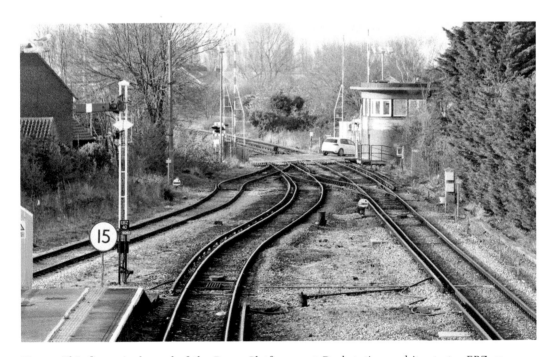

Fig. 43. This figure is the end of the Down Platform 2 at Deal station and its starter EBZ 40. This time the signal is track circuit plated, as is the trailing crossover ground disc towards the box. The engineer's siding has a store of track materials, including hardwood crossing timbers. The vestiges of an end loading dock and buffer stops are also there. The engineer's siding has a ground disc, not track circuited this time, to signal exit from the siding, while the running line is protected by a single railed trap point. March 2016.

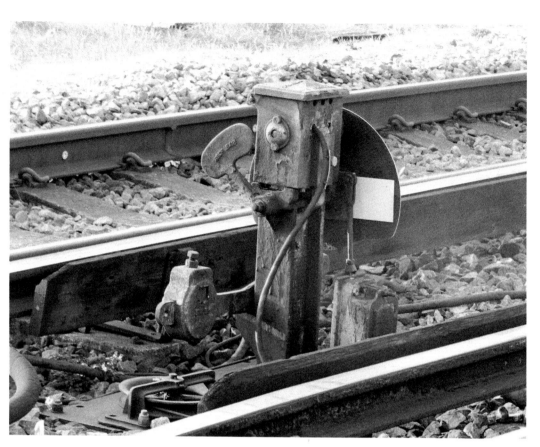

Fig. 44. Finally at Deal is the partner to the track circuited ground disc we saw in Fig. 43, which is across the crossing by the box. The pulley to the left of the signal transmits the signaller's pull to pull the disc off or go. The grey box with the vertical rod is a position transmitter. When the lever in the box is pulled, the grey curved plate swings up and obscures the rearward facing light (backlight) to indicate to the signaller that the signal has answered the lever pull. The arm and counterweight return the signal to danger when the lever in the box is set to normal. Note the boarding for the live conductor rail. The backlight cover has the initials RSCo for Railway Signalling Company on the rear of the backlight cover. RSCo became part of Westinghouse in 1920. Although the lamp is now electrically lit there would have been an electrical connection for a 'lamp out' indicator in oil lamp days. March 2016.

Deal signal box is 90 miles 43 chains (145.7 km) from Charing Cross via Chelsfield and Canterbury West.

Dover Priory (−)

Date Built	SE&CR Type or Builder	No. of Levers or Panel	Ways of Working	Current Status (2016)	Listed Y/N
1930	Southern Railway Type 12	Nx Panel	TCB	Emergency use only	N

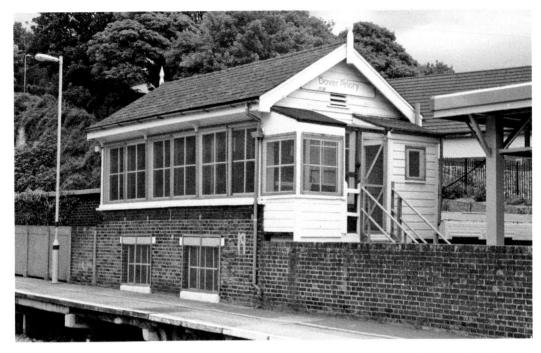

Fig. 45. Dover Priory is a product of the SR's modernisation of the station in the 1930s but has been updated since with modern wire mesh defences. Folkestone East took over its signalling in 1998, although the Nx panel has been retained for emergency use. When in emergency mode the box is subsidiary to Folkestone East. August 2009.

Dover is the main cross-channel ferry port, although it has seen a decline in recent years due to the opening of the Channel Tunnel at nearby Folkestone. The French railway SNCF operated a train-ferry service until 1994, when the tunnel opened. The station for this service was Dover Marine, which closed some years ago and is now a listed building and cruise terminal. There had also been Town and Harbour stations, while Marine also went under the name of Dover Western Docks. As with Deal, Dover Priory was originally a terminus station of the LC&DR that was named 'Dover Town'; upon the renaming to Priory, the SER named their station Dover Town in the hope that travellers from afar might think their station was more convenient for the town.

As Dover was seen as the end destination for two railways companies the mileage is calculated twice: Dover Priory station to Charing Cross via Ashford is 77 miles 23 chains (124.4 km); Dover Priory station to Charing Cross via Chelsfield and Canterbury is 77 miles 26 chains (124.44 km).

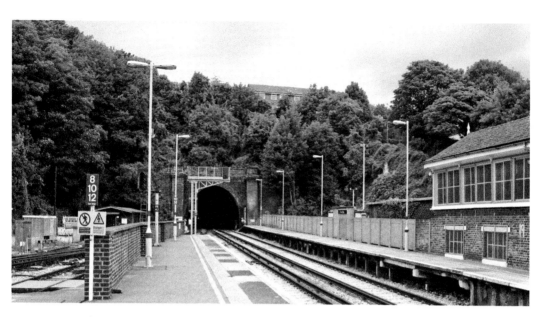

Fig. 46. This is the view towards Priory Tunnel, which measures 158 yards (144 m) and leads onto the junction for Canterbury and Deal and Ramsgate. Note that the Up main line signal is a modern LED unit and the bay Platform 3 an older multi-head signal. Both signals are plated YE for Folkestone East. The platform that the box is standing on is typical of a wartime extension and the original, more solid cast-concrete version is next to it. Note that the lines are bi-directionally signalled. August 2009.

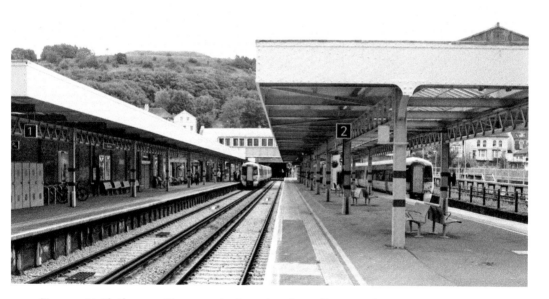

Fig. 47. At Platform 1, Class 375 is departing for Folkestone through the 684-yard (625 m) Chatham Tunnel. At the time of writing in early 2016 this route is closed due to a land slip. Platform 3 sees another Class 375, No. 375712, which has arrived into the bay platform on a terminating service. To the right of Platform 3 are three carriage sidings with basic maintenance facilities. August 2009.

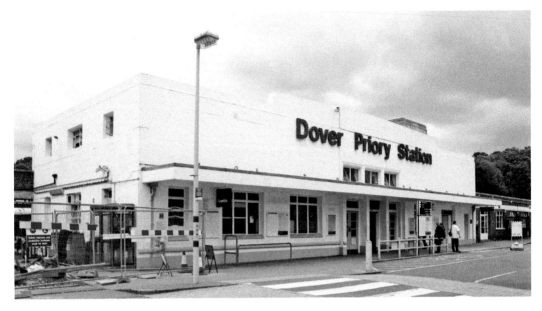

Fig. 48. Art Deco is exemplified in the frontage of Dover Priory station. August 2009.

Canterbury Area and Folkestone Harbour

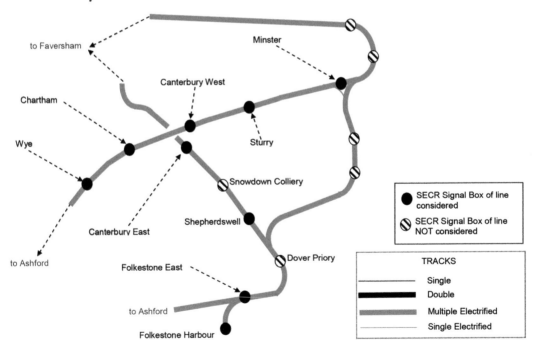

Canterbury Area and Folkestone Harbour.

Fig. 49 puts Canterbury at the heart of this largely agricultural area of fruit and hop growing and, more recently, wine production. Canterbury is the spiritual home of the Anglican Church and Canterbury Cathedral is its focus. Canterbury is a UNESCO world heritage site. Folkestone has seen more changes than all the other ferry ports with the advent of the Channel Tunnel and, while the railway complex around the tunnel has prospered, the ferry port scene has declined.

Minster (EBE)

Date Built	SE&CR Type or Builder	No. of Levers or Panel	Ways of Working	Current Status (2016)	Listed Y/N
1929	SR Type 12	70	AB/TCB	Active	N

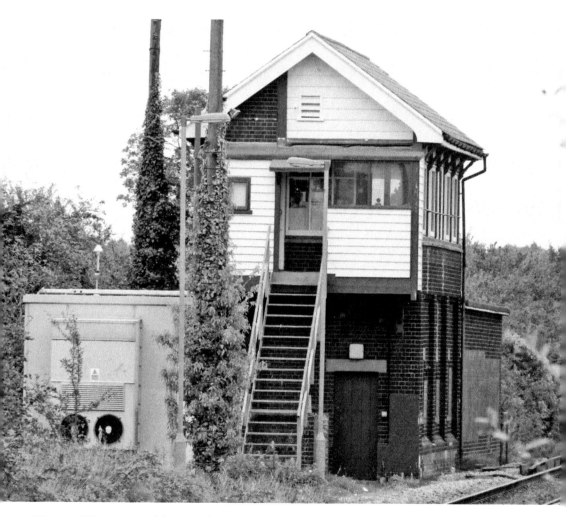

Fig. 50. Minster signal box is thoroughly modernised with the walkway removed, unlike Sandwich. This extends to the track layout, which is fully track circuited, while points are electrically operated. October 2015.

Minster is an ancient village with ecclesiastical connections as well as the name. It is also the junction of lines from Ramsgate to Canterbury to Dover.

The line was originally built in 1846 as part of the connection between Ashford, Canterbury West and Ramsgate by the SER. In 1847 a connection to Deal and Sandwich was put in, but this terminated in a bay platform and passengers wishing to go to Ramsgate or Canterbury had to change trains. The station started off as Minster in 1846 and, after four changes of name, mostly associated with either Thanet or Junction, has ended up the same in 2016.

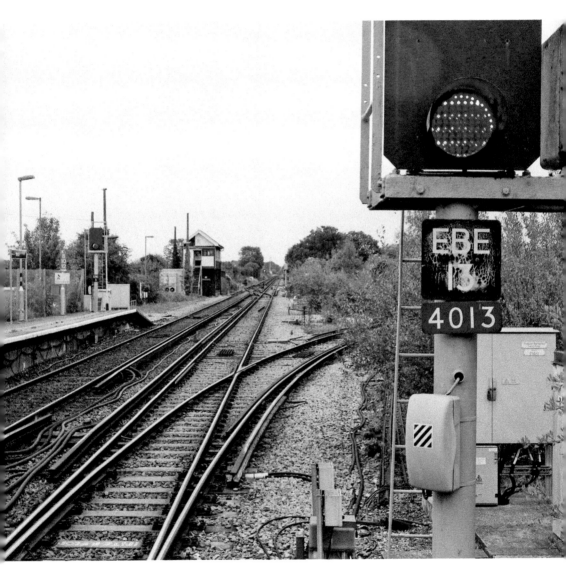

Fig. 51. The double track leads off to and from Ramsgate with the branch line to Sandwich, Deal and Dover off to the right. The platform starter for wrong line running has a junction component to it as well as a signal post telephone. Note the succession of aspects down the line to Ramsgate and the trailing crossover in front of the box. October 2015.

Fig. 52. Class 375 No. 375817 is ready for a departure to Canterbury West and the formation of the 1847 bay platform is clearly visible on the left. There is a facing crossover where the front of the EMU is, so as to enable Down trains travelling from Canterbury West to get across to the Sandwich Deal and Dover loop line. October 2015.

Minster signal box is 81 miles 74 chains (131.85 km) from Charing Cross via Chelsfield and Canterbury West.

Sturry (ST)

Date Built	SE&CR Type or Builder	No. of Levers or Panel	Ways of Working	Current Status (2016)	Listed Y/N
1892	Saxby & Farmer Type 12a (SER)	IFS Panel	AB	Active	N

Sturry station was built in 1846 and advertised as being 'Sturry for Herne Bay', which is pushing it a bit considering that Herne Bay is 6 miles (10 km) away over open fields.

Sturry signal box is 72 miles 58 chains (117.04 km) from Charing Cross via Chelsfield and Canterbury West.

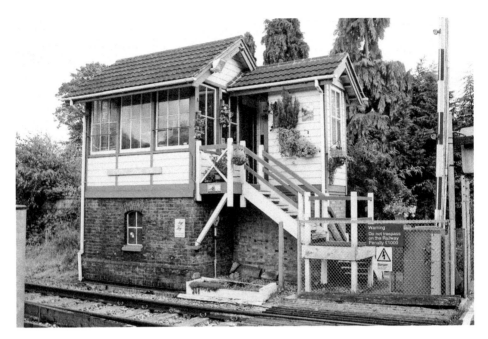

Fig. 53. The roof is tiled as opposed to quarried slate but, apart from that and the square plastic gutters, the signal box looks markedly original. Windows especially are difficult to replicate satisfactorily but here it has been achieved. There is even a locking frame window.

The retro feel is enhanced by the 1960s-era DANGER red flash enamelled sign and the fire bucket with the rounded bottom. The latter feature was popular because, with a rounded bottom, a bucket was less likely to be pressed into service mopping floors or as a coal container for the stove. The extension on the steps end of the box was sometimes used for a gate wheel when level crossings were operated mechanically from inside the box and interlocked with points and signals in the lever frame. August 2009.

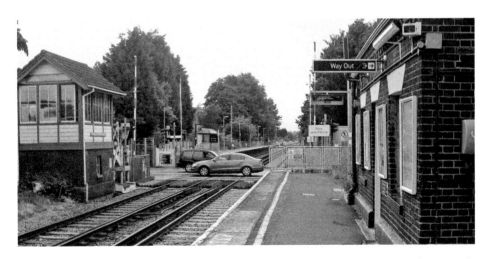

Fig. 54. Sturry station has staggered platforms, and this layout is popular where goods facilities are limited; this leads to a minimal land take. The signal box was converted into a pure gate box with no block post responsibilities and then in 2004 it was re-converted into a block post. August 2009.

Date Built	SE&CR Type or Builder	No. of Levers or Panel	Ways of Working	Current Status (2016)	Listed Y/N
1928	Southern Railway	72 SE&CR Frame	AB/TCB	Active	Y

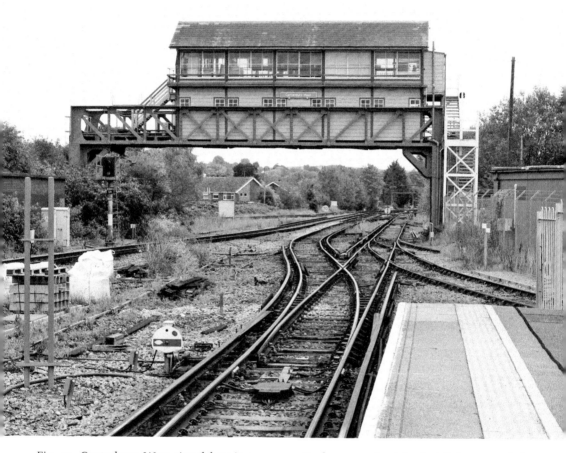

Fig. 55. Canterbury West signal box is a comparatively rare animal in that it is suspended above the tracks and only the North Eastern Railway has survivors of this form to any degree in Britain. The ground disc signal in the foreground tells us there are wire-worked signals here. October 2015.

There was some speculation that Canterbury West signal box was originally installed at Blackfriars Junction in London, but it seems that the box is simply a wooden SR design, chosen to minimise the weight on the gantry that supports it. The station originally had four tracks running though it with the platforms where they are now, so the inner two tracks were for passing traffic and the service passenger trains were put into loops.

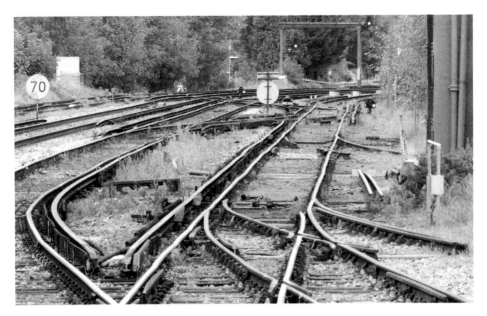

Fig. 56. The tracks towards Sturry and Minster reveal a couple of unusual features. The yellow-and-black ground disc in the middle distance displays a yellow aspect, which means that the signal is a stop signal only in the direction to which the signal may be cleared. Other movements can pass the signal without it being cleared. This is to allow a train to pass the signal without the signal needing to be selected off all the time, as in shunting moves.

The second is nearer the camera. The three way or tandem point nearest the camera has a trap point as the first point. October 2015.

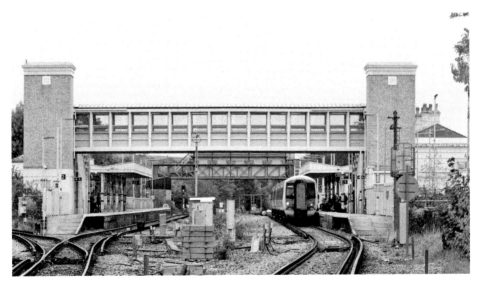

Fig. 57. Canterbury West station with Class 375 No. 375623, which is ready to depart and to head for St Dunstans road crossing and Ashford. The track branching off before Platform 2 is described as the 'DOWN LOOP'. This line had originally been Platform 3 for the Whitstable branch trains. The branch closed in 1931. October 2015.

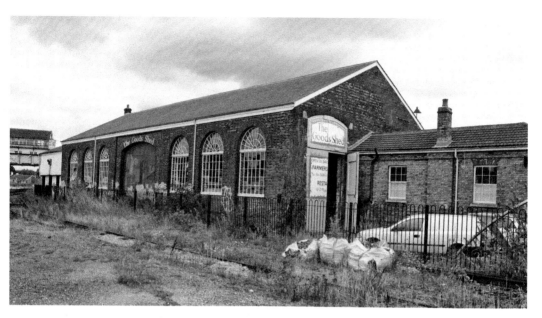

Fig. 58. The former goods shed at Canterbury West is now a farmer's market; the inside is remarkably original down to the whitewashed walls but without a crane. August 2009.

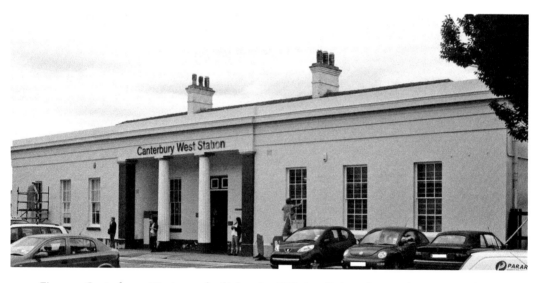

Fig. 59. Canterbury West was built by the SER in 1846 and was always more busy than Canterbury East, built by the LC&DR. August 2009.

Canterbury West signal box is 70 miles 34 chains (113.3 km) from Charing Cross via Chelsfield.

Chartham (–)

Date Built	SE&CR Type or Builder	No. of Levers or Panel	Ways of Working	Current Status (2016)	Listed Y/N
circa 1880	SER	12 levers & IFS unpanelled	Gate	Active	N

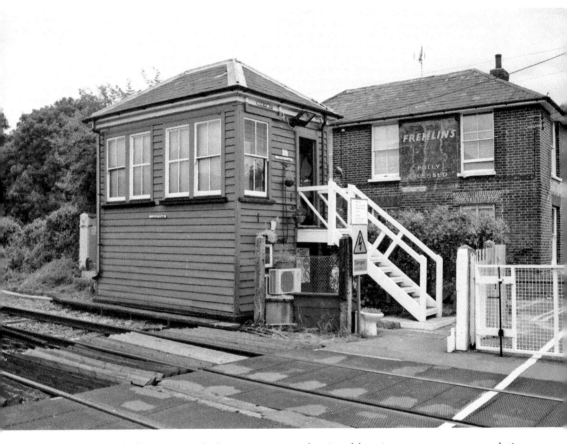

Fig. 60. Although the station is lacking in interest, the signal box is a veteran structure dating to around 1880. Chartham must hold the record for having the smallest and most difficult to see name board. Gardening has been done here as there are only the gates to worry about. The signal box has only two working levers for the gate locks and wicket gate locks. The slots for the signals are operated from the IFS switches. August 2009.

At variance with the residents of most other villages, Chartham's own resisted the arrival of the SER in 1844 and the village's name was omitted from the Act of Parliament at their request. It was not until 1859 that a perfunctory two-platform station with clapboard waiting shelters was built.

Chartham signal box is 67 miles 8 chains (107.99 km) from Charing Cross via Chelsfield.

Wye (–)

Date Built	SE&CR Type or Builder	No. of Levers or Panel	Ways of Working	Current Status (2016)	Listed Y/N
circa 1880	SER	2, Ground frame IFS unpanelled	Gate	Box itself Closed	N

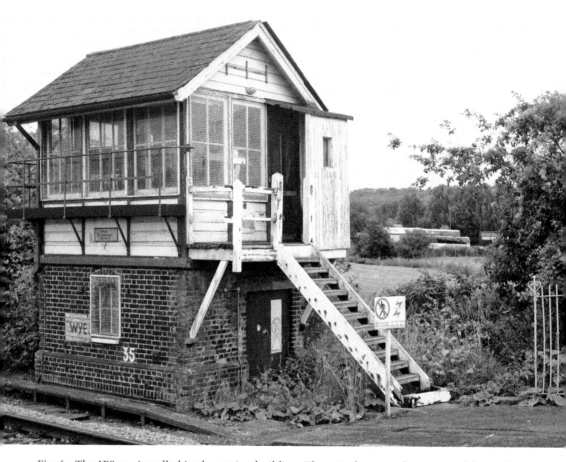

Fig. 61. The IFS are installed in the station building. There is also a two-lever ground frame that locks and unlocks the crossing gates and wicket gates. The ground frame gates are locked shut, and the key is removed, securing them shut. The key is then inserted in the IFS to operate the signal slot. August 2009.

Wye was recently voted the third best place to live in Britain by a broadsheet newspaper.

The station building is very distinctive and even the clapboard waiting shelter has survived. The signal box ceased to be used when semaphore signals were removed in 2003.

Fig. 62. The ground frame at Wye is opposite the gates and at the opposite end of the platform and track side to the signal box building. The gates were hand operated at the survey date. There was a separate gate box when the signal box itself was a block post. August 2009.

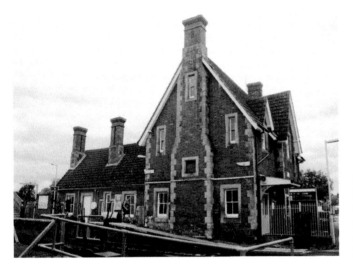

Fig. 63. The station building is very fine for a wayside village station. Note the window in the chimney stack – a most unusual feature. August 2009.

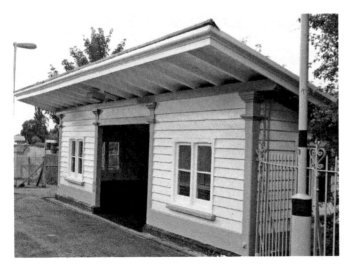

Fig. 64. The opposite Platform 2 has a clapboard waiting shelter and even this has pleasing features, such as the detail of the pillars. August 2009.

Wye station is 60 miles 32 chains (97.2 km) from Charing Cross via Chelsfield.

The journey backtracks somewhat to take in the route from Canterbury East towards Dover and then Folkestone.

Canterbury East (CB)

Date Built	LC&DR Type or Builder	No. of Levers or Panel	Ways of Working	Current Status (2016)	Listed Y/N
1911	SE&CR	28 LC&DR Frame	AB	Closed	Y

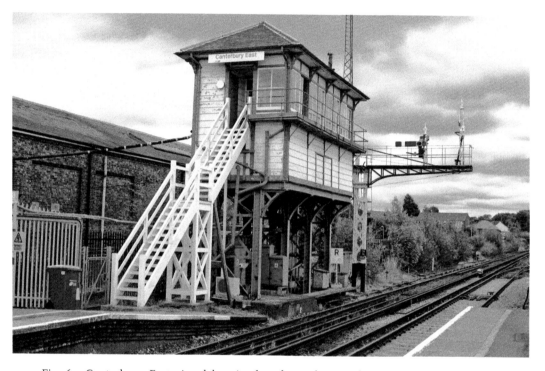

Fig. 65. Canterbury East signal box is also elevated, as with Canterbury West, but is more conventionally achieved without straddling the tracks. There were also lattice post semaphore signals at the original survey date. The bracket signal outside the box has a redundant small post or doll on the bracket. After 1956 there was a loop line that was used to hold slower trains while boat trains rushed past. The left-hand post signalled entry into the loop and the right the Down main line to Dover. This left the taller doll, or post, without an arm. Nevertheless the lattice post has an elegance and economy of weight, if not of cost to manufacture. The view is towards Dover. August 2009.

The station was built by the LC&DR and, although the box is later, it has an LC&DR frame. The box was closed in 2011 when the semaphore signalling was removed, but the first survey pre-dates those changes.

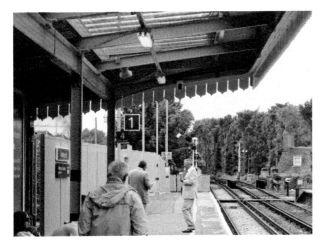

Fig. 66. Platform 1 at Canterbury East towards the absolute block working to Faversham has its SR rail post starter signal off for an imminent arrival. Across the platform are a lattice post semaphore and a track circuited ground disc on a post. This elevation is an attempt to overcome a sighting issue for the trailing crossover signal caused by the platform and girder bridge nearby. Faversham is in the Up direction. August 2009.

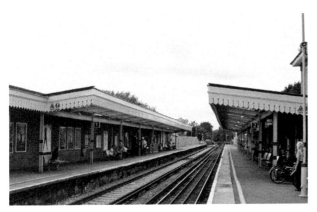

Fig. 67. The station buildings at Canterbury East of the LC&DR seem less grand than the SEC structures of Canterbury West and see less traffic. The former has about 1 million passengers a year, the latter about 2 million. The platform canopies are from the station at Lullingstone, which the SR had partly built before the outbreak of the Second World War. August 2009.

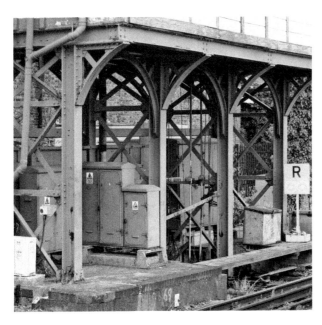

Fig. 68. The signal box detail shows how point rodding is transmitted from the levers on the operating floor to the trackside. The semaphore signals have chains to transmit their movement. August 2009.

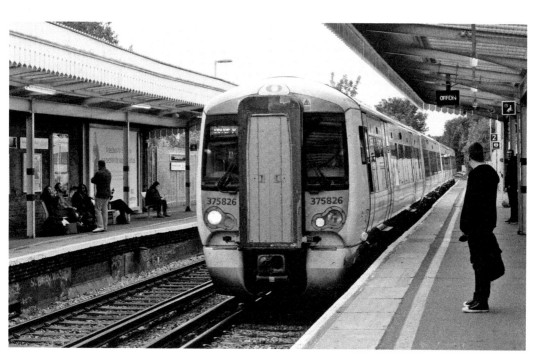

Fig. 69. Class 375 No. 375826 is bound for Dover on the Down line and has the confirmation that the starter signal is off from the OFFDN caption repeater suspended from the canopy on Platform 2. October 2015.

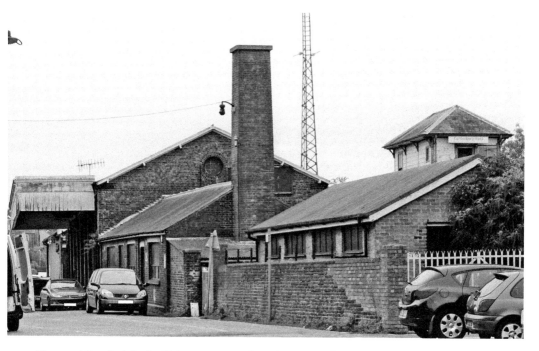

Fig. 70. After freight facilities were transferred to Canterbury West in 1965 the goods shed at Canterbury East lasted as a parcels depot until about 1970. October 2015.

Canterbury East signal box is 61 miles and 69 chains (99.56 km) from Victoria Station via Herne Hill.

Shepherdswell (SH)

Date Built	LC&DR Type or Builder	No. of Levers or Panel	Ways of Working	Current Status (2016)	Listed Y/N
1878	LC&DR	23 LC&DR Frame	AB	Closed	Y

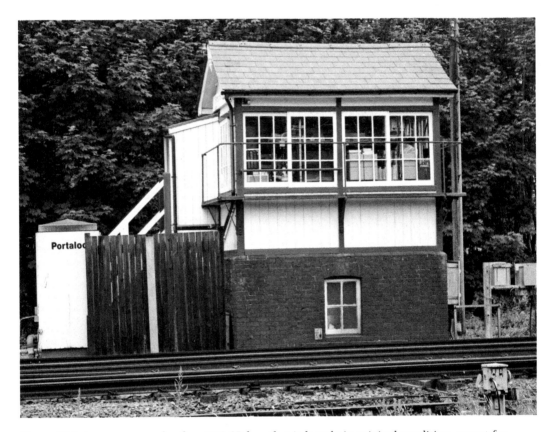

Fig. 71. This is a rare example of an LD&CR box that is largely in original condition, except for its replacement windows and plastic roof slates instead of slate slates. Note the small armed shunting signal in the foreground. August 2009.

This is one of those occasions where the description on the Act of Parliament for the line does not exactly match the accepted form. The accepted form is Shepherd's Well.

Shepherd's Well sidings were, up until 1985, a storage facility for coal wagons for Tilmanstone Colliery and up the line towards Canterbury East was Snowsdown Colliery signal box.

Fig. 72. At Shepherd's Well station the Down platform still has a semaphore starter signal with sighting board. The tunnel is Lydden Tunnel at 1 mile 609 yards (2.17 km) in length. August 2009.

Fig. 73. This is an interloper from the SER at Shepherdswell but is on the nearby preserved East Kent Railway. This box top is a visitor centre and was built in about 1887. August 2009.

Fig. 74. Another East Kent Railway exhibit is this lattice post signal; however, it does not seem to control the 'slam door' EMU stock movements. August 2009.

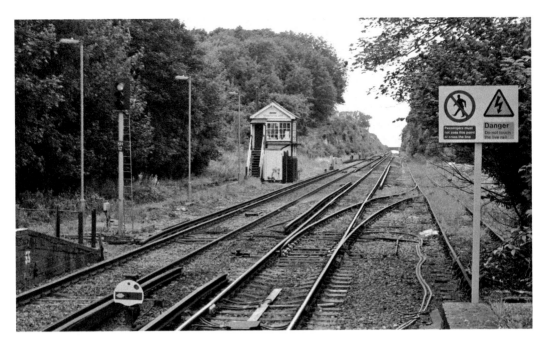

Fig. 75. Shepherdswell signal box and the Up platform ramp on the left. The siding behind the box used to hold coal wagons. There is a tall lattice post signal on the right-hand Down side in the distance. The track circuited ground disc signals a reversing move into the Down siding and loop on the right. August 2009.

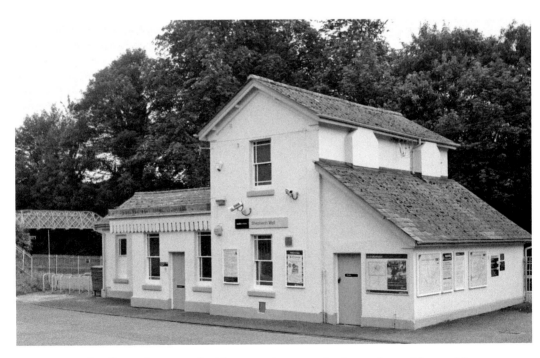

Fig. 76. Shepherd's Well station building survives mostly intact but without chimneys. August 2009.

Shepherdswell signal box is 71 miles and 51 chains (115.29 km) from Victoria station via Herne Hill.

The journey continues past Dover Priory, a previous destination, to Folkestone East signal box.

Folkestone East (EY)

Date Built	SE&CR Type or Builder	No. of Levers or Panel	Ways of Working	Current Status (2016)	Listed Y/N
1962	BR Southern Region Type 18	Nx Panel	TCB	Active 2016	N

Fig. 77. Folkestone East signal box is another of the BR power boxes and is of a similar type to Rainham. The rear view emphasises the massive amount of space needed for relay locking considering that these boxes covered much larger areas than a conventional mechanical unit. The remains of the sidings and connection to the harbour are in front of the box. There had been a small loco depot here in steam days, BR coded 73H, a sub shed of Dover. August 2009.

The town of Folkestone has long been associated with the ferry service to Boulogne as well as Calais and Ostend. The SE&CR and the GWR ran through trains from Birkenhead to Folkestone, with coaches for other destinations. There were no fewer than four railway stations in the town and only Folkestone Junction, latterly Folkestone East, had closed at the survey date, converted into a staff halt.

Folkestone East signal box is 70 miles 74 chains (114.14 km) from Charing Cross via Chelsfield.

Folkestone Harbour (EBB)

Date Built	SE&CR Type or Builder	No. of Levers or Panel	Ways of Working	Current Status (2016)	Listed Y/N
1933 Moved to site	Saxby & Farmer	22	TCB	Closed	N

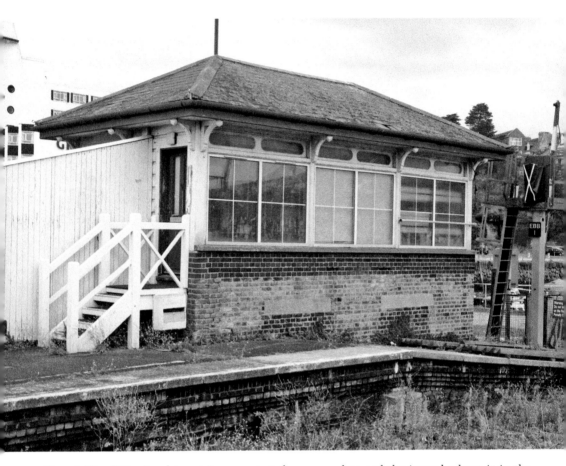

Fig. 78. The EBB1 signal is not in use yet at the survey date and the inner harbour is in the background. Although the signal box closed in 2006 it has been used as a refuge for the crossing attendant. August 2009.

Folkestone Harbour signal box is second hand at this site and was moved here in 1933. It isn't known when the box was originally built but it has the look of a structure of the 1880s.

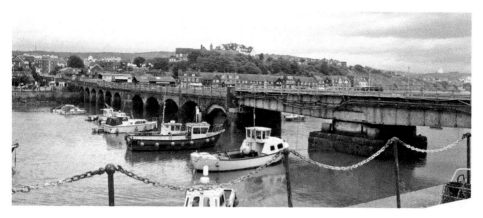

Fig. 79. The connection to the main line is via a gradient of 1 in 30, one of the steepest on any main line. At the end of the gradient coming down from the town is a swing bridge that connects the inner and outer harbours; this is on the right of the figure. In steam days, up to four tank engines would be used to assist trains up the gradient towards the town. The line was electrified in 1961 and the steam shed closed in the same year. Lever 13 in the box is to release the swing bridge and lock all signals to danger. August 2009.

Fig. 80. The Up line on the left is out of use at the survey date but the Down line on the right would appear to have a future and its own signal. The Down line is worked as a single line by a Pilotman working. PILOT means Person In Lieu of Token, where a member of staff acted as a physical token and was required to accompany the train, so that there could only ever be one train in the section. The box is on the opposite platform. August 2009.

Fig. 81. Folkestone Harbour station has only the far platform in use at the survey date. Note the mechanical weighing scales on the near platform and modernistic ferry terminal building in the background. The platform canopies are a later feature, and the station originally had an overall roof. The station officially closed in 2014. August 2009.

Folkestone Harbour signal box is 72 miles 2 chains (115.91 km) from Charing Cross via Chelsfield.

Maidstone Area and the South Coast

Maidstone is the county town of Kent, and an ancient and important place in history as well as a trading town along the River Medway and a focus for the 'Garden of England' produce.

Hastings has long been a holiday resort historically visited by people from all over Britain serviced by special trains. In common with many seaside resorts it also still has semaphore signals in 2016.

The not-to-scale schematic diagram, Fig. 82, portrays a journey that runs roughly from north to south on the Medway Valley Line to a junction at Paddock Wood, ending up at the ancient port and picturesque town of Rye.

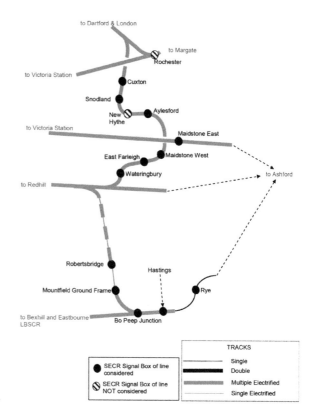

to Dartford & London
to Margate
Rochester
to Victoria Station
Cuxton
Snodland
Aylesford
New Hythe
to Victoria Station
Maidstone East
East Farleigh
Maidstone West
to Redhill
Wateringbury
to Ashford
Robertsbridge
Hastings
Mountfield Ground Frame
Rye
to Bexhill and Eastbourne LBSCR
Bo Peep Junction

	TRACKS	
● SECR Signal Box of line considered		Single
		Double
⊘ SECR Signal Box of line NOT considered		Multiple Electrified
		Single Electrified

Maidstone area and the South Coast.

Cuxton (CX)

Date Built	SE&CR Type or Builder	No. of Levers or Panel	Ways of Working	Current Status (2016)	Listed Y/N
1887–1889 estimate	SER	15 Brady of 1892	AB then TCB	Active	Y 2013

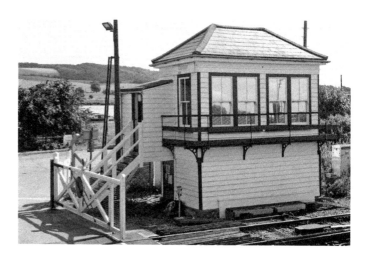

Fig. 83. Cuxton signal box is an essentially original box with clapboard walls, walkway with cast-iron brackets and wooden steps. It doesn't come with the listing but there is also a fine view of the River Medway as well as Network South East (NSE) name board. August 2009.

Cuxton is a rare breed in the south-east of England that still had manually operated gates at the survey date.

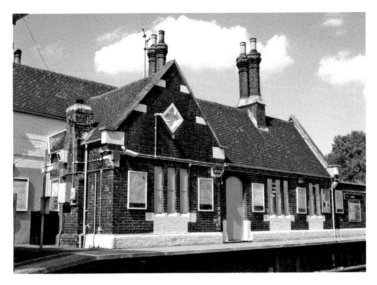

Fig. 84. The station building is full of importance as the transport hub or the village that it was when it was built. The buildings were in use up until 1989 but work is going on to find a new use. The chimney stacks are an example of a mundane item made to be decorative. August 2009.

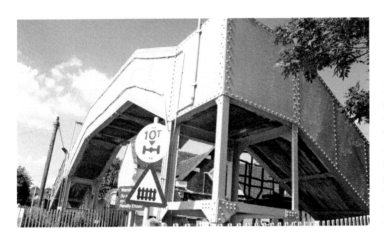

Fig. 85. The footbridge at Cuxton is unusual and has age to it. It was built using Steam Age water tower technology of riveted steel plates on a steel frame. The footway for passengers, however, is of wood. August 2009.

Cuxton signal box is 33 miles and 39½ chains (53.9 km) from Charing Cross via the Dartford Loop.

Snodland (EDM)

Date Built	SE&CR Type or Builder	No. of Levers or Panel	Ways of Working	Current Status (2016)	Listed Y/N
1870s estimate	SE&CR	IFS Panel	AB then TCB	Closed	N

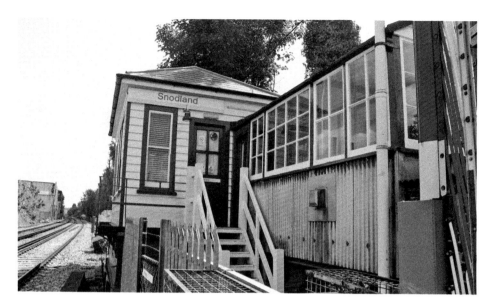

Fig. 86. Snodland signal box has another manual operating legacy in the form of the hut or extension on the side of it. This was to house the manual gate wheel that opened and closed the gates from within the box. The gate wheel rotation would impart a linear motion through a screw jack, which would be transmitted through linkages to the gates and often under the road where the crossing was. This had the signalling advantage of being readily able to be interlocked with signals. The example here has been disconnected in favour of barriers, manually controlled from within the box at the first survey date of 2009. The layout here is unusual in that the gate wheel mechanism is often located on the ground floor at locking room level and here there was clearly not enough room. August 2009.

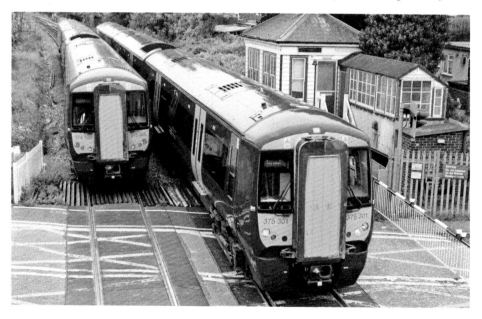

Fig. 87. Snodland box after closure is seeing a busy time. EMU Class 375 No. 375305 on the left accelerates towards Maidstone West, while classmate No. 375301 slows for a station stop before setting off for Strood, Dartford and London Bridge station. October 2015.

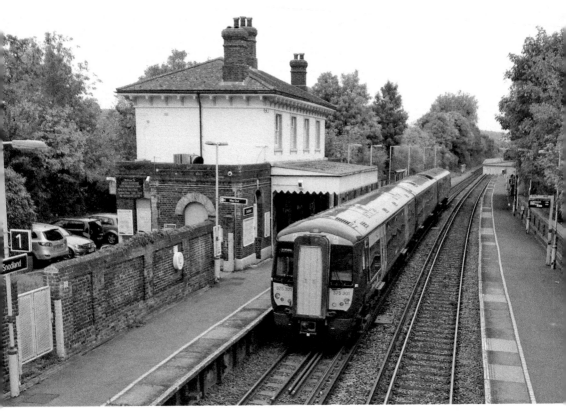

Fig. 88. No. 375301 stands at Platform 1 on its way north towards Dartford. The station building resembles a large detached house in Victorian days, which it was in the sense that the stationmaster, or porter signalman (always men then), at smaller stations lived on the job upstairs. October 2015.

Snodland is an expanding town on the River Medway that had industrial roots in lime and chalk extraction and paper making.

Snodland signal box is 36 miles and 64 chains (59.2 km) from Charing Cross via the Dartford Loop.

Aylesford (AF)

Date Built	SE&CR Type or Builder	No. of Levers or Panel	Ways of Working	Current Status (2016)	Listed Y/N
1921	SE&CR	IFS Panel	AB then TCB	Active	Y 2013

Aylesford is a medieval crossing of the River Medway and has recently (2015) lost its connection with the paper industry. Both the station and signal box are listed here.

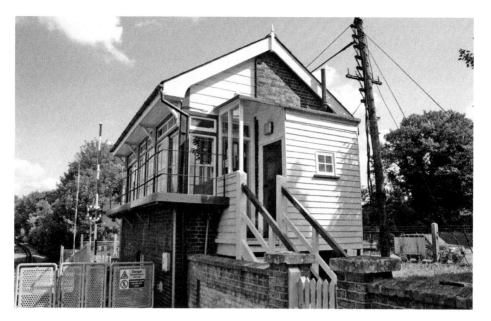

Fig. 89. The signal box is listed as it is the first of the type that was to become a Southern Railway standard after Grouping and the last of the SE&CR designs. The box looks largely original except for the windows and toilet block added on. August 2009.

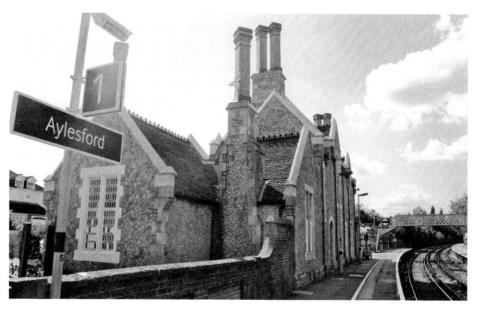

Fig. 90. Aylesford station building was constructed in 1856 but is reminiscent of the Tudor age. The window frames, though, are of cast iron in sections rather than carved stone. The roof has an intricate fish scale pattern in the tiling and it is set off with cockscomb ridge tiles. The chimney stacks are statement pieces and the dressed stone at the corners, mullioned windows and gables contrast with the rough stone of the walls. The platform has a banner repeater LED signal as an advance warning of the status of the red starter signal we can see off the end of the platform beyond the footbridge. August 2009.

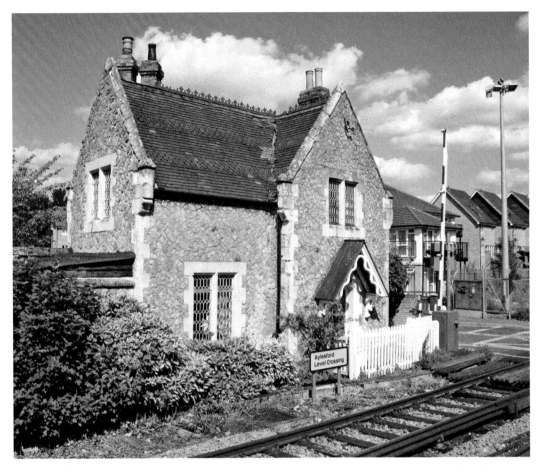

Fig. 91. Aylesford crossing keeper's cottage is in the same style as the station building but this time has a gabled porch with decorative barge boards. August 2009.

Aylesford signal box is 38 miles and 74 chains (62.64 km) from Charing Cross via the Dartford Loop.

Maidstone West (MS)

Date Built	SE&CR Type or Builder	No. of Levers or Panel	Ways of Working	Current Status (2016)	Listed Y/N
1899	Evans O'Donnell for the SE&CR	115	AB then TCB	Active	Y

Maidstone's railway layout has no doubt ensured a good deal of inconvenience to passengers over the years. As well as East and West stations there is also Maidstone Barracks. There was a single-track branch line running from just past the signal box across the River Medway to a mill.

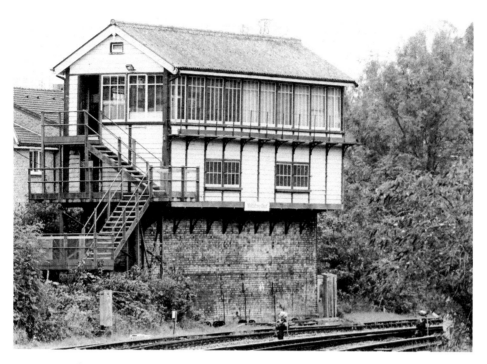

Fig. 92. Maidstone West signal box is an imposing building and an unusual one in that it was built by the signalling contractor Evans O'Donnell. It also has some semaphore signalling, while the bottom front edge of the box has six pulleys that are used to transmit the movement on the frame by wire to the ground signals. There is a pair of ground signals in the figure with their backs to us. October 2015.

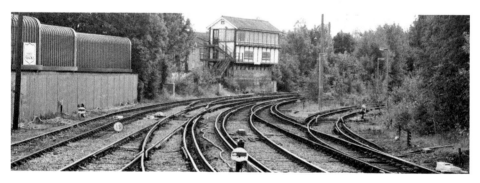

Fig. 93. The south end of the station and box are shown. From the far left, the crossover is the end of a loop and the head shunt or neck continues on the far left. Next to that is the bay platform with an engineer's Grampus wagon planted out as a decorative feature; however, the bay is clearly not in passenger use as neither track is electrified. On the right-hand side is a carriage siding, with its grey point motor, some illumination for servicing lights and a pair of ground disc exit signals, only one of which would appear to be in use now. The black miniature poles and signal wires are visible on the right of the tracks. The carriage siding is off a loop that serves Platform 1 at the station and has a double-railed trap point to protect the running line. The two main running lines are in the centre of the picture. Note that, of the two ground discs facing us, only the one that refers to the running line nearest the camera is track circuited. August 2009.

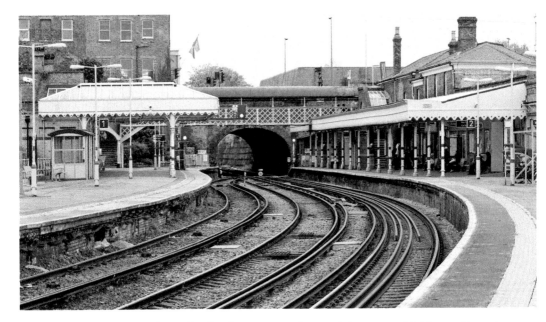

Fig. 94. Back to 2016 and three ultra-bright LED signals guard the way to Maidstone Barracks station, Strood and Dartford. The Platform 1 loop line referred to in Fig. 93's description is on the left. The somewhat restricted layout with the bridge over London Road and the curvature add to the charm of the scene, attractive to a modeller. October 2015.

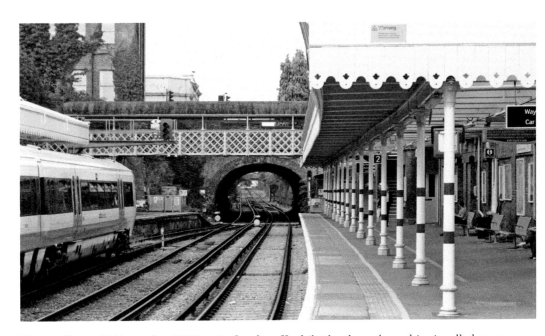

Fig. 95. Class 466 Networker EMU waits for the off while the through road is signalled on or danger. The Platform 2 signal on the right is for bi-directional running and would not normally be off unless the left-hand line was inoperative. Maidstone Barracks station is about ½ mile (0.8 km) up the gradient, through the 53-yard (48 m) London Road Tunnel, and can just be seen in the distance. October 2015.

There is a change of direction and mileage change here: Maidstone West signal box is 44 miles and 54 chains (71.9 km) from Charing Cross via Chelsfield.

Maidstone East (ME)

Date Built	SE&CR Type or Builder	No. of Levers or Panel	Ways of Working	Current Status (2016)	Listed Y/N
1962	BR Southern Region Type 18	Westinghouse power frame & Nx Panel	TCB	Active 2016	N

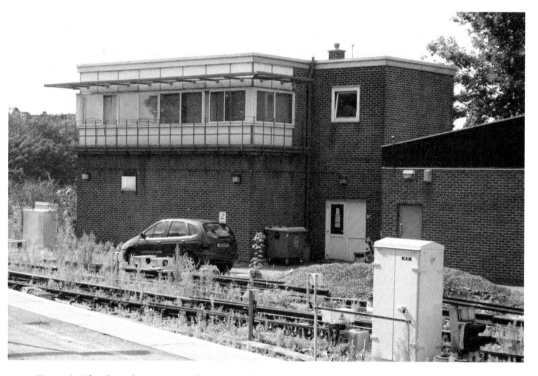

Fig. 96. The box here is similar to Folkestone East but has rather different innards. The Westinghouse power frame had originally been used at Cannon Street in London up until 1957. The Nx panel was built by TEW of Nottingham and controls the line from east of Otford near Sevenoaks in the west to the west of Ashford in the east. Note the modernised ground signal with two captions and possible routes in the foreground. August 2009.

Maidstone East is on a completely separate line from West, running from Victoria station to Ashford with other permutations.

Maidstone East signal box is 39 miles and 72 chains (64.2 km) from Victoria station via Herne Hill.

The journey resumes on the north–south Medway Valley line.

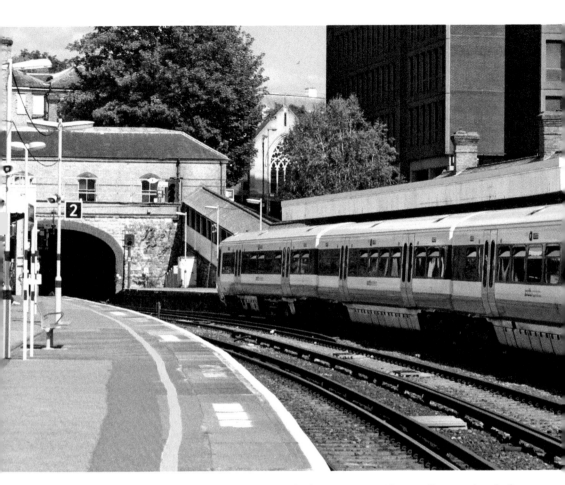

Fig. 97. Class 466 Networker EMU pauses at Platform 1 on Maidstone East station before departing towards Otford and Swanley Junction towards Victoria station. August 2009.

East Farleigh (EF)

Date Built	SE&CR Type or Builder	No. of Levers or Panel	Ways of Working	Current Status (2016)	Listed Y/N
1892	SER	11, Brady frame 1892	AB then TCB	Active	N

This box is similar to Cuxton in its frame manufacturer and these gates across the road were also hand operated at the survey date.

East Farleigh signal box is 42 miles and 75 chains (69.1 km) from Victoria station via Herne Hill.

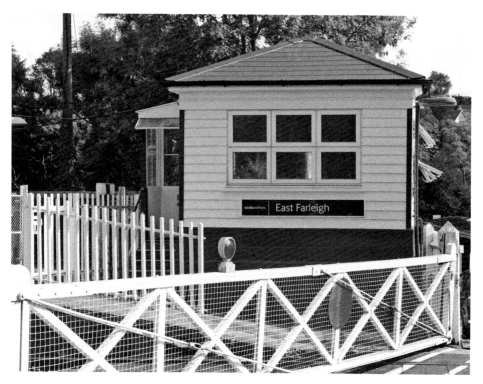

Fig. 98. East Farleigh signal box. The box is of the economical clapboard style – cheap to produce and able to be put up rapidly. August 2009.

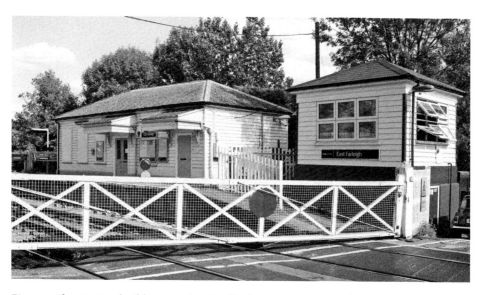

Fig. 99. The station building on the Up Platform 1 is now Grade II listed. The classic SER timber station building had a canopy running the length of the building, as did the smaller buildings of many other railway companies. At East Farleigh this early example has canopies over the doors only. Ironically the brick-built goods shed was demolished some years ago. August 2009.

Wateringbury (WB)

Date Built	SE&CR Type or Builder	No. of Levers or Panel	Ways of Working	Current Status (2016)	Listed Y/N
1893	Saxby & Farmer Type 12a SER	9 IFS unpanelled	AB then TCB	Active	Y

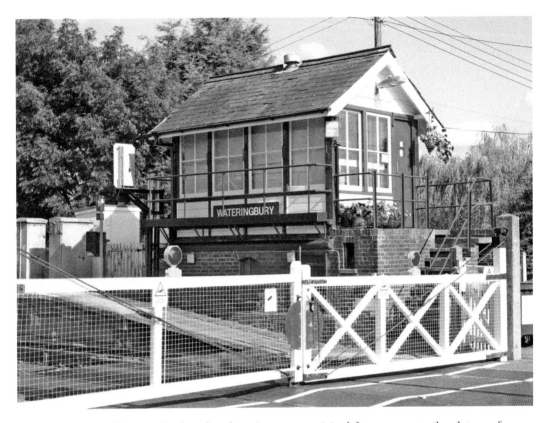

Fig. 100. The signal box is also listed and retains many original features up to the slate roof, although the chimney has been replaced by a cowl after coal stoves were done away with. The platform that supports the steps is clearly a later addition. Gardening has re-appeared with a display of surfinias and other bedding plants. The manually operated gates have a chain and padlock. Note the differing styles of gate construction with the gate nearer the box seemingly the older style. The IFS is for Teston Lane Crossing under CCTV control and is just over 1 mile (1.6 km) from the box. August 2009.

While East Farleigh station was ancient but listed, Wateringbury is in the Tudor style of Aylesford with gothic overtones and built in the grand style. Wateringbury station is Grade II listed by Historic England.

Wateringbury signal box is 39 miles and 72 chains (64.2 km) from Victoria station via Herne Hill.

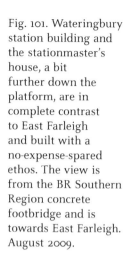
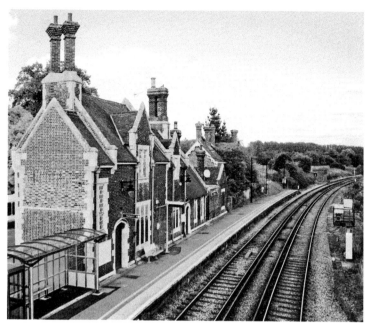

Fig. 101. Wateringbury station building and the stationmaster's house, a bit further down the platform, are in complete contrast to East Farleigh and built with a no-expense-spared ethos. The view is from the BR Southern Region concrete footbridge and is towards East Farleigh. August 2009.

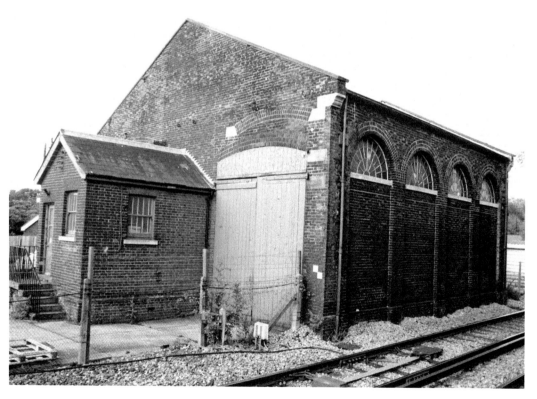

Fig. 102. The goods shed at Wateringbury is listed. The arched windows impart a slightly grand terminus station style. Note the remains of soot from a steam engine that are still visible above the doorway. August 2009.

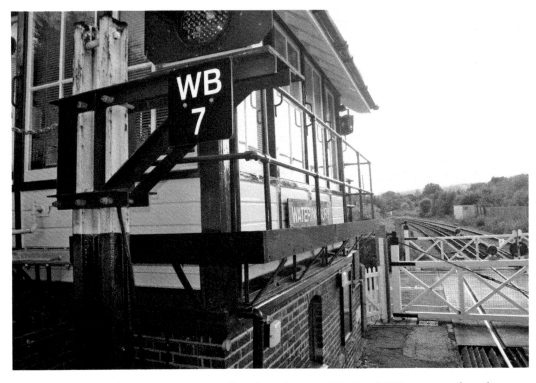

Fig. 103. A final detail at Wateringbury is the relatively new LED signal, WB7, mounted on the Southern Railway bull head rail semaphore signal post. August 2009.

The journey continues to Paddock Wood and then diverges south towards Tunbridge Wells and the South Coast.

Robertsbridge (RB)

Date Built	SE&CR Type or Builder	No. of Levers or Panel	Ways of Working	Current Status (2016)	Listed Y/N
1893	Saxby & Farmer Type 12a SER	23	TCB	Active	N

Into the county of East Sussex now, and Robertsbridge is a very pretty village south of Tunbridge Wells. It is also home to the Rother Valley preserved railway.

Robertsbridge was originally a junction; the line joined the Paddock Wood to Ashford line at Headcorn. Hereabouts the SER discovered that the line's tunnels had been constructed by the contractor with insufficient thickness in the brick lining. Some of the linings fell down in 1855. After the contractor was successfully sued, the SER relined the tunnels; however, this meant that the loading gauge was then smaller – and so it is to this day. This has meant that the worst examples of restricted bore tunnels have been converted to single track.

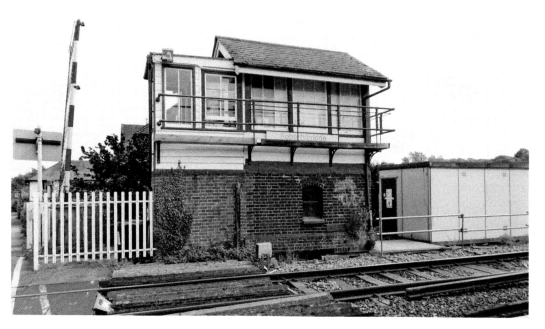

Fig. 104. Robertsbridge signal box seems a small structure for twenty-three levers. Robertsbridge releases Mountfield Ground Frame to operate, with lever 7 in the box to perform that function. There is a trailing crossover and an engineer's siding, which runs in behind the platform where the bay was; however, this is a trailing point whereas the bay was a facing point. The latter has a ground frame that is released from the box. In addition to the road crossing right outside the box, Robertsbridge also supervises Riverhall crossing near Mountfield Ground Frame by utilising CCTV. July 2015.

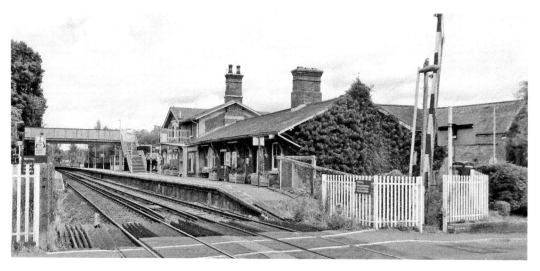

Fig. 105. Robertsbridge main station building is in front of the former brick-built goods shed, which is in good condition but is now a gardening equipment centre. The signal box is the other side of the road crossing. The bay platform for the junction with the Kent & East Sussex Light Railway ran in behind the main platform and the Rother Valley Railway's headquarters is behind the goods shed. There is also a period waiting shelter on the opposite platform. July 2015.

Robertsbridge signal box is 49 miles and 54 chains from (79.94 km) from Charing Cross station via Chelsfield.

Mountfield Ground Frame (MF)

Date Built	SE&CR Type or Builder	No. of Levers or Panel	Ways of Working	Current Status (2016)	Listed Y/N
1975	BR Southern Region Hut	Stevens frame 11	Shunt Frame	Active 2016	N

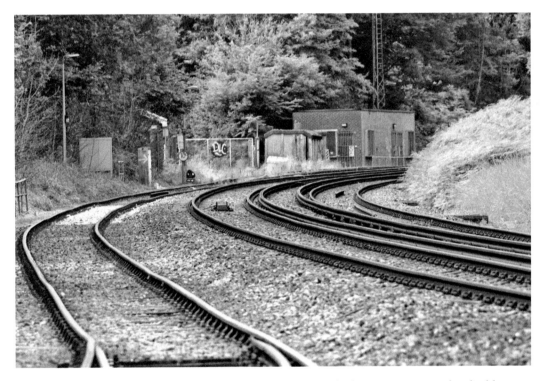

Fig. 106. Mountfield Ground Frame is the brick building with the GSM-R mast. The double track (at this point) main line sweeps around the curves on the right, while the freight-only non-electrified branch is on the left. This is the headshunt, leading to loops and sidings, while the actual connection to the British Gypsum mine is through the white gate with the red target. The eleven-lever frame by Stevens controls six signals and three points, and there are two spare levers. The view is towards Robertsbridge, Tonbridge and Mountfield Tunnel, which is single track at 526 yards (480 m). July 2015.

Mountfield Ground Frame was built to service the rail-connected facility of British Gypsum, who manufacture plaster and plasterboard sheets for the building industry. The ground frame controls the freight-only connection with the Tonbridge–Hastings Line.

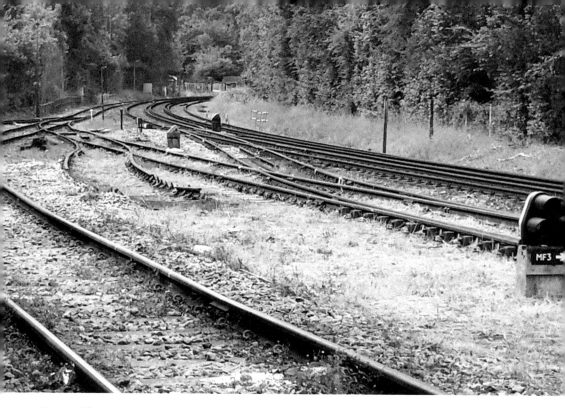

Fig. 107. The photograph shows the connection to the main line and the signal MF 3 is one of a pair to signal movements over the crossover connection with the main line. There is now just a run-round loop and a siding from the three loops that were there in previous years. Class 66 locomotives regularly haul 1,800-tonne trains from the site. July 2015.

Mountfield Ground Frame is 51 miles and 78 chains from (83.65 km) from Charing Cross station via Chelsfield.

Bopeep Junction (BJ)

Date Built	SE&CR Type or Builder	No. of Levers or Panel	Ways of Working	Current Status (2016)	Listed Y/N
circa 1912	SER	24 IFS Panel	AB from Hastings TCB	Active	N

Bopeep Junction got its name from a local public house as there wasn't a sizeable settlement after which to name the place at the time. The coming of the railways created another seaside resort – St Leonards-on-Sea – and this was often twinned with Hastings on BR advertising posters of the 1950s and 1960s.

Bopeep Junction signal box is 60 miles and 65 chains from (97.87 km) from Charing Cross station via Chelsfield and the mileage is also calculated over the LB&SCR to Brighton, which is 32 miles 72 chains (52.95 km).

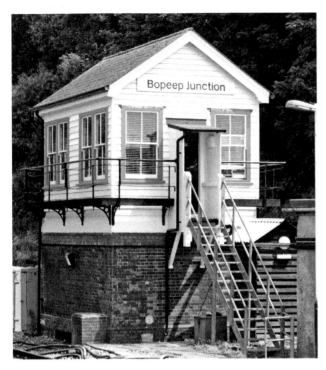

Fig. 108. Bopeep Junction signal box is in the double junction of lines that connect the coast line with the Tonbridge Hastings line, which includes Robertsbridge. Ways of working have been modified over the years so that the box now works absolute block from Hastings but track circuit block to Hastings and TCB elsewhere. The IFS panel is to control the entrance to the St Leonards (West Marina) carriage washing, inspection and covered depot. The box's easterly sphere of control extends to some way inside the ½ mile (0.8 km) Bopeep Tunnel. After that and through St Leonard's Warrior Place station is Hastings' signal box control area. June 2008.

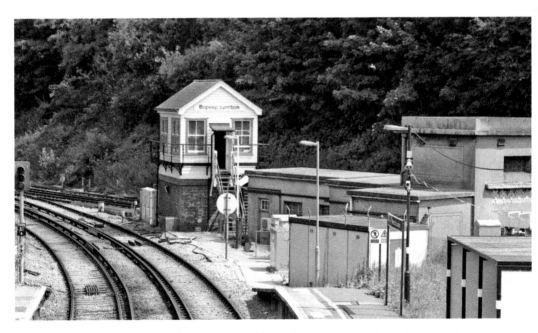

Fig. 109. The picture was taken from the footbridge at West St Leonards station and shows not only Bopeep Junction signal box but the associated electricity substation to power the tracks with the 750 v DC. These structures are necessary every so often so as to maintain a third rail constant voltage supply. To the left is the way east to Hastings and Rye and Bopeep Tunnel; to the right is the carriage depot, servicing sheds and the LB&SCR at Bexhill-on-Sea. Behind the camera is the line back up to Robertsbridge. June 2008.

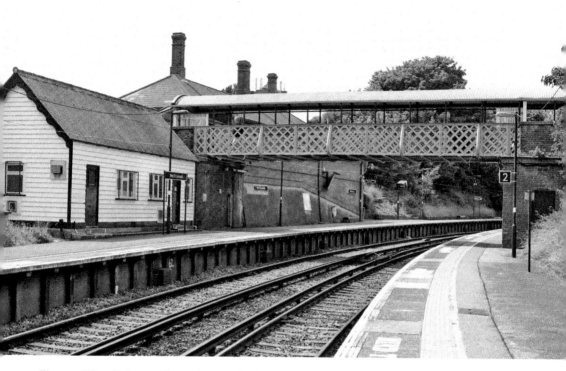

Fig. 110. West St Leonards station was built in 1887 and therefore falls into the economic style of SER architecture, where timber buildings found favour as opposed to the no-expense-spared Gothic cathedral genre. However a substantial brick-built station building survives with three chimney stacks. June 2008.

Hastings (EDL)

Date Built	SE&CR Type or Builder	No. of Levers or Panel	Ways of Working	Current Status (2016)	Listed Y/N
1930	SR Type 12	84	AB, to Ore TCB	Active	N

Hastings was famous almost a thousand years ago; the town was first a fishing port, which it still is, then a seaside cure for the rich, and finally a seaside resort for everyone. The original SER station was extended from having two to four platforms and the resort was a premier South Coast rail destination with services beyond London. There were four through platforms originally, but Platform 1 has been turned into an Ashford facing bay to enable step-free access from station building to platforms.

The mileage changes here and Hastings signal box is 82 miles and 24 chains (132.45 km) from Charing Cross station via Chelsfield and Ashford.

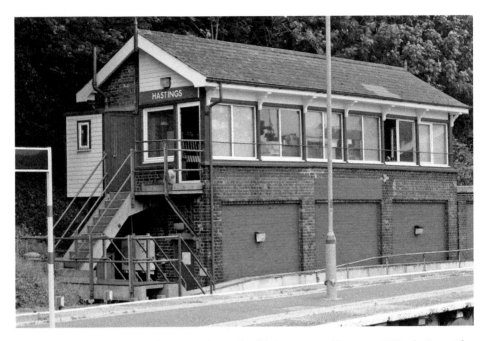

Fig. 111. Hastings signal box is of SR build but resembles an SER design. The eighty-four-lever frame points to the rear wall when the levers are 'normal'; this meant that the stove was originally to the front, and the repair to the slate roof was visible when the stove was removed. Of the eighty-four levers, only fifty remain in use for points signals and facing point locks. The name board is in the SR or BR Southern Region style. All the points on the layout are electrically operated by lever through switches. However, there are mechanically worked semaphore signals here at the east end of the station and absolute block working. The line to Ore (the next station east) is double track, TCB, but from there on the working is Tokenless Block – this will be explained under the section for Rye that follows this piece. July 2015.

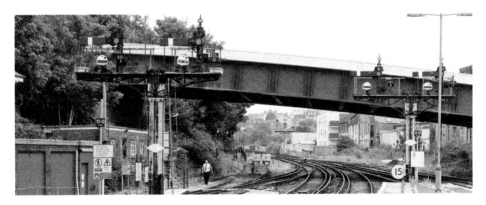

Fig. 112. This shot at Hastings portrays many of the semaphore signals remaining at this location. The four platform signals read, from right to left, Platforms 1, 2, 3 and 4. Each platform signal has an elevated ground signal that controls entry to the carriage sidings. The bracket posts are old rails in Southern Railway fashion with lattice post 'dolls' topped off by elegant finials. There is a modernised triple bracket signal beyond the over bridge and ground signals out near the carriage sidings. July 2015.

Fig. 113 illustrates the bracket signal that is on the end of Platforms 1 and 2 in some detail. The angle cranks to convey the signal wire movement are larger for the ground discs and the final connection to the larger signal arm is a chain to the counterbalance lever. The double-railed trap point for Platform 1 has its grey point motor next to it, and this works in conjunction with the associated point that admits access to Platform 1. An EMU is present in one of the pair of carriage sidings known as Park Sidings beyond the road bridge. July 2015.

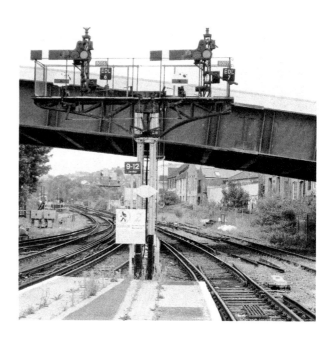

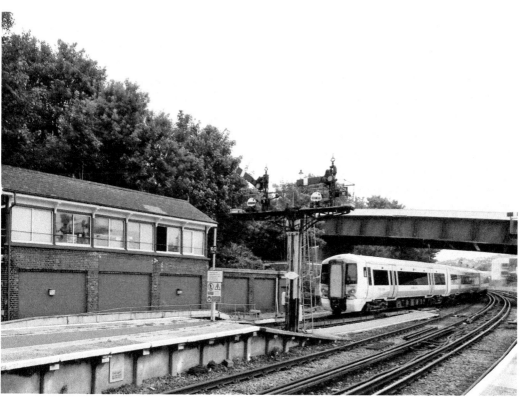

Fig. 114. Platform 4 at Hastings sees the departure of Class 375 No. 375908 for the Ashford direction but it will only get as far as Ore, the next station, as that is where the electrified tracks stop. In track circuit block areas, as soon as the first vehicle has passed the signal the signal goes to red or danger. July 2015.

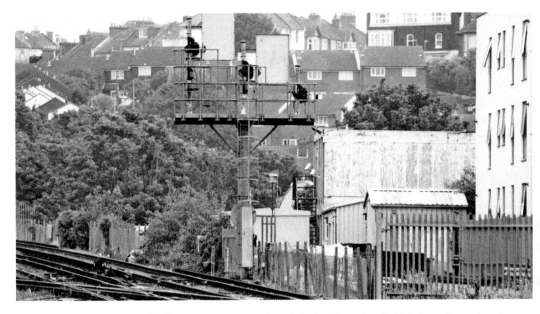

Fig. 115. Beyond the over bridge at Hastings is the triple bracket signal. This has three signal arms and they are as follows from right to left:

1. The un-electrified sidings to the right of Platform 1, smaller signal arm, no sighting board.
2. Platform 1 entry signal, middle post.
3. Platform 2 entry signal left hand post.

The post heights are indicators as to speed, with Platform 2 having the highest speed; the siding signal would not usually admit passenger trains with passengers in them. There are two double slips in view concerned with movements into the carriage sidings and these equate to a scissors crossover, except in a much smaller space and consequently with a lower speed limit. There is a further double slip in the carriage sidings. The carriage siding space at Hastings was nowhere near enough with summer traffic at its peak because of the restricted site, so a fan of carriage sidings was built at Ore but they are now out of use. July 2015.

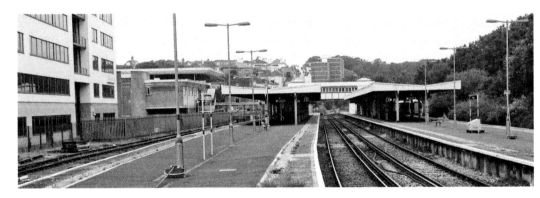

Fig. 116 shows the station from the east end and looking back to Bopeep Junction. The sidings on the far left are part of the former goods yard and refer to the signal under sub-paragraph 1 above. Platform 1 is now a bay next to that and Platform 2 has a colour light signal at the end of it. The train on Platform 4 is the one we saw in Fig. 121. July 2015.

Rye (RY)

Date Built	SE&CR Type or Builder	No. of Levers or Panel	Ways of Working	Current Status (2016)	Listed Y/N
1894	Saxby & Farmer Type 12a (SER)	30	TB	Active	Y

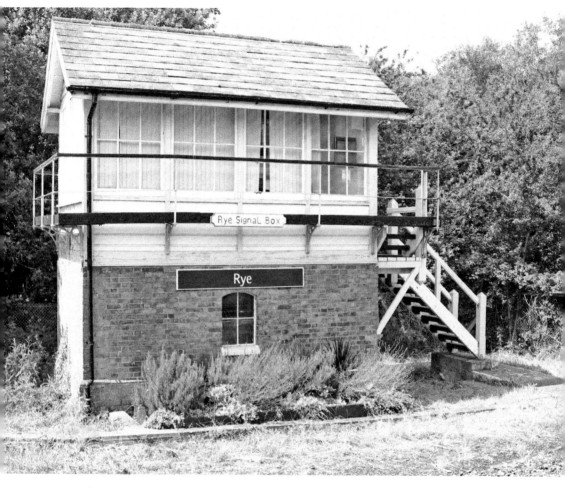

Rye signal box, Fig. 117. The open space in front of the box was occupied by a long siding in double-track days. The line was singled in 1979 and it works by the Tokenless Block system; it is marketed as the 'Marshlink Line'. June 2008.

Rye is one of the historic Cinque Ports; the fishing fleet and small harbour add to the attractions of this charming town, whose main activity now is tourism.

The station building was the work of a William Tress and is generally much admired. The SE&CR waiting shelter is also a survivor on the opposite platform.

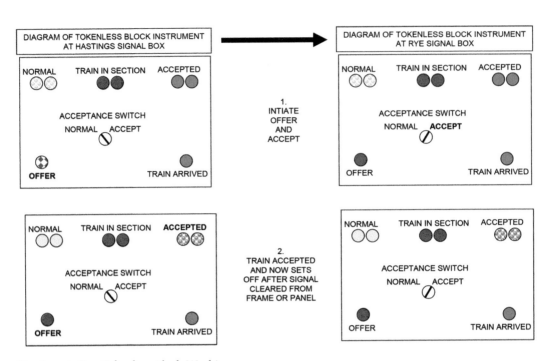

Hastings to Rye Tokenless Block Working:
1. Initiate and Accept, 2. Train departs down single line

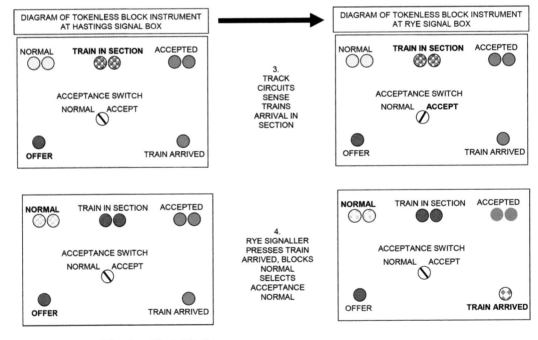

Hastings to Rye Tokenless Block Working:
3. Track Circuit – Train In Section, 4. Train Arrived

Tokenless Block Operation

Let us suppose that a diesel train from Hastings is to be passed to Rye.

The Tokenless Block instrument has three indications possible, of which only one is ever displayed at once. These are the double sets of lights displayed at the top of the cabinets in Figs 118 and 119.

1. Normal (line blocked or no permissions granted) in grey.
2. Train in Section.
3. Train Accepted.

There is a two-position Acceptance switch, with Normal and Accept positions.

At the bottom of the cabinet are two push buttons: OFFER and TRAIN ARRIVED.

The Tokenless Block works as below (note: there are variations on the precise nature of the instruments but the principles remain the same).

As described in Fig. 118:

1. To pass the train from Hastings to Rye the signaller at Hastings presses the Offer button.
2. Rye selects Accept, this is reflected on Hastings' TB instrument as Train Accepted. This status is also reflected on Rye's TB instrument.
 This then locks all the signals on the single line from Rye to Hastings at danger.

As described in Fig. 119:

3. When the train has arrived in the section at Hastings, the track circuits sense this and turn both tokenless block instruments at Hastings and Rye to Train in Section.
4. When the train has arrived at Rye, complete with tail lamp, the signaller at Rye selects Train Arrived and the instrument indications at both places revert to Normal. This operation is interlocked with any points on the route and the system is then ready to dispatch another train in either direction. Similar arrangements also exist between Rye and Ashford signalling centre for the single track section from Rye to Appledore.

Rye signal box is 71 miles and 34 chains (114.95 km) from Charing Cross station via Chelsfield and Ashford.

The line continues to Appledore, whereupon it becomes double track and this is also the junction with the single track branch to Dungeness nuclear power station. This area of marsh land is also home to the Romney, Hythe & Dymchurch Light Railway heritage miniature railway.

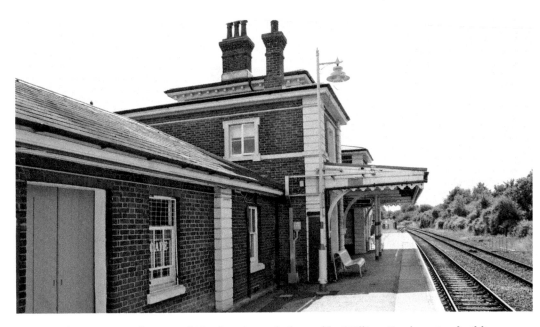

Fig. 120. The view towards Ore and Hastings is partly framed by William Tess's station building. The colour light signal at the end of the Down Platform 2 signals re-entry to the single-line section and there is a crossover here, part of which acts as a trap point. The SR parcels depot extension is on the left and was the enticing Fat Controller Café at the survey date. June 2008.

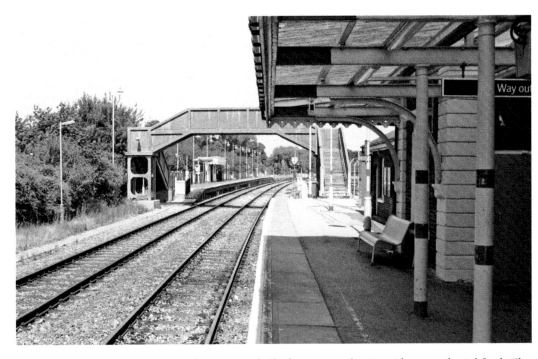

Fig. 121 is the opposite view to the staggered Platform 1 on the Up side towards Ashford. The 1960-built concrete footbridge looks as though it might be earlier, and the SE&CR waiting shelter on Platform 1 is earlier. The section signal for the single line can just be seen. June 2008.

Western Area

The railways were not always satisfied to maintain their lines within the boundaries of their titles. Obvious examples are the Midland Railway at Bournemouth and the LNER, with a branch line in north Wales. The SER promoted the line as a means of avoiding London when accessing the channel ports and holiday resorts.

Fig. 122 is a very much simplified representation of the lines south of London and hints at what a tangled web of railway companies and their lines were – and still are.

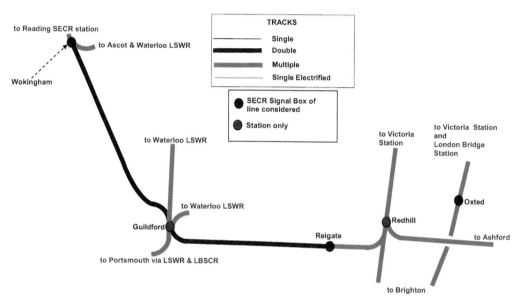

Western Area.

Wokingham (WM)

Date Built	SE&CR Type or Builder	No. of Levers or Panel	Ways of Working	Current Status (2016)	Listed Y/N
1933	Southern Railway Type 12+	40	TCB	Active	N

Wokingham, together with Reading, forms part of Britain's Silicon Valley and the station's passenger level reflects this with over 2 million passengers a year.

The SER originally had its own station at Reading, which was tacked onto the GWR main route and junction station with a connection to what had been Brunel's station. The GWR had offered the SER access to its own station, which would have speeded up through traffic.

It now has its own platforms as it has retained the SR third rail means of traction. The line south to Redhill is termed the North Downs Line and, although electrification has been discussed over many years, the recent acquisition of Class 166 Networker Turbo DMUs has seen the subject relegated to the backburner.

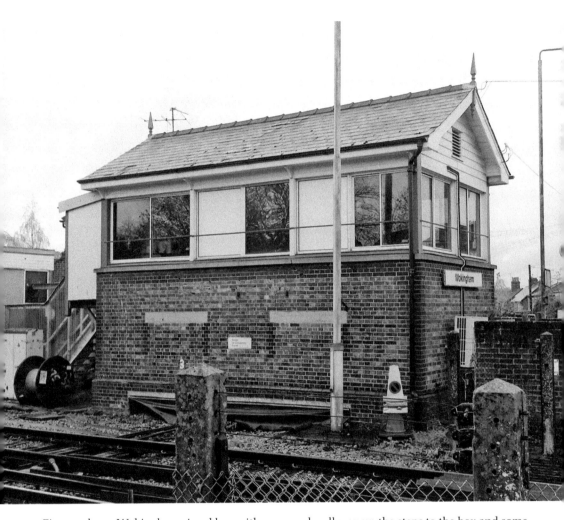

Fig. 123 shows Wokingham signal box with a covered walkway up the steps to the box and some point rodding emerging from the tunnel. November 2014.

Wokingham signal box is 62 miles and 3 chains (99.84 km) from Charing Cross via Redhill.

Fig. 124. The Ascot & Waterloo line diverges to the right, while the line to Redhill carries straight on towards the camera. There is a carriage siding on the left and three semaphore ground signals. From left to right, they control:

1. Carriage siding exit, which is protected by a double-railed trap point.
2. Reversal over the crossover, which is where the second coach of the EMU is, from the Up Redhill line, which is the right hand of the non-electrified pair.
3. Reversal over the same trailing crossover from the Up Ascot line, which is on the far right of the picture and the signal is elevated.

The Class 450 No. 450103 takes the double junction to Ascot out of the recently rebuilt Wokingham station and under the pedestrian crossing bypass foot bridge, which is built partly of old rails. The box is on the left just after the footbridge. April 2016.

Fig. 125. This view is from the Ascot line towards the double junction and the trailing crossover referred to in the previous figure is clearly visible. Of more interest are the ground signals. So far we have been used to seeing a ground disc and a spectacle with differing coloured lenses, through which a light is shone to illustrate the aspect. Here with all three ground signals, the illuminated angle of the stripe is all that conveys to the train driver what aspect the signal is showing. Note the rod- and lever-worked points with the facing point lock just to the left of the elevated disc signal. April 2016.

Reigate (RG)

Date Built	SE&CR Type or Builder	No. of Levers or Panel	Ways of Working	Current Status (2016)	Listed Y/N
1929	SR Type 11b	24 & IFS unpanelled	TCB	Active	N

Into Surrey now and Reigate is a delightful and ancient town that mostly houses part of the London commuter population. This is the furthest extent of the non-electrified section from Wokingham along the North Downs line and the station has the third rail, which is present from all points east of Reigate.

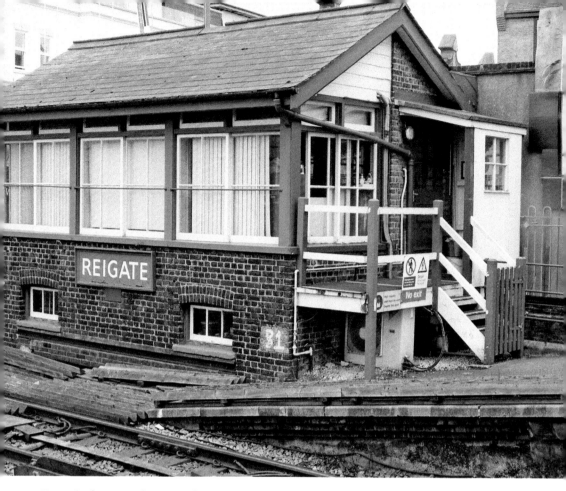

Fig. 126. The SR replacement for an SER signal box that was originally opposite the goods yard at the other end of the platform. With the road crossing just to the left of the box there was also a gate box where the present box is. The box has unusual small hopper windows above the main glazing. The locking room windows still have curved brick arches at the top and this sort of ornamental decoration was being reduced in the cash-strapped inter-war period. The box has the twenty-four-lever frame mounted so that the levers are in the 'normal' position point to the rear wall. The IFS is for the section between Betchworth and Gomshall. This section saw a FGW-branded Class 166 catch fire at Buckland Crossing in November 2015; no one was injured. The name board is a period piece. Notice how the rodding tunnel has been bricked up in a different and later style to the original brickwork. March 2016.

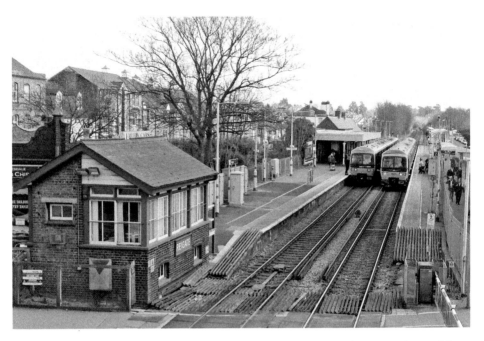

Fig. 127. This is the view from the pedestrian crossing bypass footbridge across the road from the station. The third rail starts right opposite the box and continues towards Redhill. The view is towards Redhill and the traffic is double diesel. Note the small ground signal between the track; this must be for the trailing crossover, which is beyond the two DMUs. March 2016.

Fig. 128. First Great Western-branded DMU Class 166 No. 166201, on the Up line and heading for Redhill, waits at Platform 1 for passengers to disembark but already has the 'off'. GWR Class 166 No. 166208 with differing roof detail to its classmate is similarly engaged but will soon depart from the Down line towards the camera and Reading. The bi-directional running signal at the end of Platform 2, which is half the length of Platform 1, RG 11 has a subsidiary elevated ground signal that is used for the two sidings on the right, only the first of which is electrified and has a stop lamp on it. March 2016.

Fig. 129. EMU Class 377 No. 377342 has arrived from Redhill on the Down line and must now regain the Up line on the left for the return journey. The crossover is set for this operation. A piece of detail for the modeller is the oily discharge between the rails on the Up line, caused no doubt by the Class 166 DMUs. March 2016.

The mileage changes, and Reigate signal box is 24 miles and 30 chains (39.23 km) from London Bridge station on the Quarry Lines.

Oxted (OD)

Date Built	SE&CR Type or Builder	No. of Levers or Panel	Ways of Working	Current Status (2016)	Listed Y/N
1987	BR Southern Region	Nx Panel	TCB	Active	N

The town is described by a broadsheet newspaper as being the twentieth wealthiest in Britain.

The railway was late arriving in 1884, after some wrangling with the LBSCR, with the resulting station a joint one. The station serves Victoria and London Bridge termini as well as the Uckfield Line.

Oxted signal box is 20 miles and 32 chains (39.23 km) from London Bridge station.

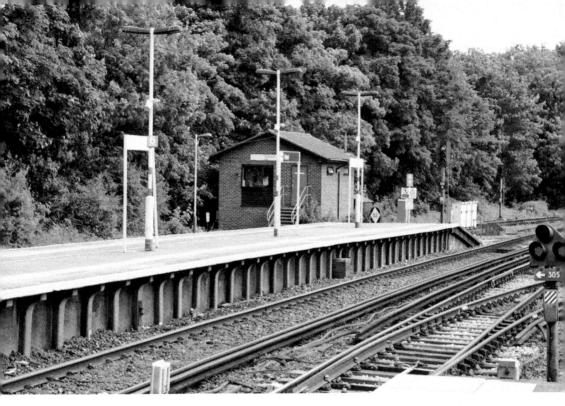

Fig. 130. Oxted signal box might best be described as the domestic garage school of architecture. The pre-fabricated concrete platforms have relics of a bygone age with pulleys for signal wires on two of the concrete beams. The elevated ground signal is for a reversing move into the Up siding. June 2006.

References and Acknowledgements

Acknowledgements

The kindness and interest shown by railway staff.

Also for John Tilly's kind permission to reproduce his photograph of Margate signal box at Fig. 21 in this book.

References

Books and printed works

Signalling Atlas and Signal Box Directory – Signalling Record Society
Quail Track Diagrams Parts 3 and 5 – TrackMaps
British Railways Pre-Grouping Atlas and Gazetteer – Ian Allan

Internet Websites

John Tilly's collection of signal box images on the web site:
www.tillyweb.biz/gallery/odyframe.htm

Adrian the Rock's signalling pages
www.roscalen.com/signals

The Signalbox – John Hinson
www.~~~~~~lbox.org

Wikipedia
www.wikipedia.org

Southern Electric Group
www.southernelectric.org.uk/features/infrastructure/dorset-resignalling/
www.southernelectric.org.uk/features/infrastructure/east-kent-resignalling/eksig03.html

Goods & Not So Goods
myweb.tiscali.co.uk/gansg/3-sigs/gndsigs.htm

Historic England
historicengland.org.uk/listing/the-list/